FRENCH A[RMIES]
SINCE 1500

FRENCH ART AND MUSIC SINCE 1500

Anthony Blunt
and
Edward Lockspeiser

with illustrations

Revised and reprinted
from
France: A Companion to French Studies
EDITED BY D. G. CHARLTON

METHUEN

FRANCE: A COMPANION TO FRENCH STUDIES
first published in 1972
by Methuen & Co Ltd
11 New Fetter Lane London EC4
Printed in Great Britain
by Richard Clay (The Chaucer Press), Ltd
Bungay, Suffolk
These chapters, revised and expanded, first published as a
University Paperback in 1974
This edition © 1974 Methuen & Co Ltd

ISBN 0 416 81650 9

Distributed in the USA by
HARPER & ROW PUBLISHERS INC.
BARNES & NOBLE IMPORT DIVISION

CONTENTS

LIST OF ILLUSTRATIONS

Sir Anthony Blunt and the publishers wish to thank the following for permission to reproduce the illustrations that appear in this book:

Burrell Collection, Glasgow Art Gallery and Museum, for nos. 19 and 22; Courtauld Institute Galleries for nos. 1, 2, 3, 5, 6, 13, 14, 24, 25, 26, and 27; Duke of Sutherland Collection on loan to the National Gallery of Scotland for no. 7; Fitzwilliam Museum, Cambridge, for no. 23; Musée des Beaux-Arts, Brussels, for no. 12; Musée du Louvre for nos. 4, 15, 16, 18, 20 and 21; Museum of Modern Art, New York, for no. 32; National Gallery, London, for nos. 17 and 28; National Gallery of Art, Washington, Chester Dale Collection, for no. 30; National Museum, Stockholm, for no. 10; Royal Collection for no. 8 which is reproduced by gracious permission of Her Majesty the Queen; State Hermitage Musem, Leningrad, for no. 29; University of Glasgow, Hunterian Museum, for no. 11; Wallace Collection for no. 9; Wallraf-Richartz Museum, Cologne, for no. 31.

EDITOR'S PREFACE

The chapters in this volume first appeared in *France: A Companion to French Studies* in 1972 (London, Methuen, x + 613 pp.). That work – ranging over French history and society, thought, literature, painting, sculpture and architecture, music, and politics and institutions from the Renaissance to the present – is inevitably lengthy and proportionately costly. It has thus been suggested that particular chapters which together provide a very useful treatment of their subject should be made available in cheaper format. That is the aim of the series to which this book belongs, covering respectively:

1 *French History and Society: The Wars of Religion to the Fifth Republic*
 (Dr Roger Mettam and Professor Douglas Johnson)
2 *French Thought since 1600*
 (Dr D. C. Potts and Professor D. G. Charlton)
3 *French Literature from 1600 to the Present*
 (Professor W. D. Howarth, Professor Henri M. Peyre and Professor John Cruickshank)
4 *French Art and Music since 1500*
 (Professor Sir Anthony Blunt and the late Mr Edward Lockspeiser)
 (with illustrations not included in the original volume)
5 *Contemporary France: Politics, Society and Institutions*
 (Professor Jean Blondel, in an expanded treatment of his subject)

Each study has been revised, with additional material where necessary, and the original brief bibliographies have been expanded into the form of bibliographical essays. Given 'the chastening insight [in Professor Sir Ernst Gombrich's words] that no culture can be mapped out in its entirety, but no element of this culture can be understood in isolation', one may regret that these chapters should be torn from their original context, and it is greatly to be hoped that those interested in individual

elements of French culture will refer to the total volume to complete their understanding. Yet it is the Editor's belief, even so, that this present book provides, at a price which most would-be purchasers can afford, a widely informative, up-to-date guide and evaluation.

His fellow contributors regretted the death of Mr Edward Lockspeiser shortly after the original publication. The Editor is grateful to Dr Brian Jeffery for undertaking to see Mr Lockspeiser's chapter through the process of republication and to prepare the bibliographical essay.

D. G. CHARLTON

Department of French Studies
University of Warwick
February 1974

FRENCH PAINTING,
SCULPTURE AND ARCHITECTURE
SINCE 1500
Anthony Blunt

The Sixteenth Century

In the years 1530–40 there occurred in French painting one of those
complete breaks which are very rare in the history of art. On his return
from captivity in Madrid, François I set about achieving his ambition
to create in France an intellectual and artistic centre which should rival
the great courts of Italy, the beauties of which he had savoured during
the Italian campaigns.[1]

The focal point of his activities was Fontainebleau, which, from being
a small hunting lodge, became within a few years one of the most
splendid palaces in Europe. Two Italian artists were called to France to
decorate it. One, Giovanni Battista Rosso (1494–1540), was a Floren-
tine; the other, Francesco Primaticcio (1504–70), was trained in Bologna
and Mantua. Their achievement can be judged from the decoration
surviving in the Galerie François I, now freed from the nineteenth-
century restoration which for long disfigured it.

What is unusual about the achievement of the First School of Fon-
tainebleau, as it is called, was that the two Italian artists did not produce
a slightly second-hand version of what they had learnt in Italy, but
created a completely new manner of decoration which was to spread
over the whole of Europe, and even to exercise influence in northern
Italy on artists of the calibre of Palladio. Its essential novelty lay in a
brilliant combination of high-relief stucco work with large painted

[1] Owing to the general scheme of the book in which this essay was first published,
this section had to be produced without illustrations, and the author was therefore
forced to concentrate on the more general characteristics of French art. In this
new edition a few plates are included but these can only give a taste of the pleasures
which the subject provides.

panels, and its hallmark was a type of decoration called strap-work, which consists of elements looking like pieces of leather or parchment cut and curled over in the form of scrolls. Panels of this strap-work were copied in engravings which were circulated throughout Europe and helped to spread the style. In their actual paintings Rosso and Primaticcio created novel variations on the style called 'Mannerism', which had recently been evolved in Italy by the members of Raphael's studio in Rome and Mantua. It was characterized by extreme elegance of forms and of gestures, elongation of proportions, and ingenuity of iconography, all features to be seen in the frescoes of the Galerie François I.

Rosso and Primaticcio swept the board as far as decorative and historical painting were concerned, but in portraiture a naturalistic style, deriving partly from Flanders and partly from Italy, continued to be practised. Much the most distinguished representative of this style was Jean Clouet (active 1516; d. 1540), who is known by a few paintings and miniatures, and by a magnificent series of portrait drawings in the Musée Condé at Chantilly. The tradition of portraiture was carried on by his son, François (before 1520–72), who was brilliantly successful in his rendering of costume but lacked the grasp of monumental form which characterized the work of his father, and by Corneille de Lyon (d. 1574), an enigmatic figure to whom a number of small and delicately painted portraits are ascribed.

In architecture the change was much less abrupt. During the first quarter of the sixteenth century French soldiers and diplomats taking part in the Italian campaigns had brought back from Lombardy, and even sometimes from further south, sculptors and craftsmen capable of executing fine Italianate decoration on the buildings then going up, which were still in a late Gothic style. The combination is sometimes awkward but can be surprisingly harmonious, as in churches such as Saint-Pierre at Caen, built by Hector Sohier between 1528 and 1545, in the Loire Valley châteaux like Chambord (begun in 1519), Azay-le-Rideau (1518–27) and the earlier part of Chenonceaux (begun 1515), and in smaller town houses, of which many are also to be found in the Loire Valley (e.g. the Hôtel Pincé at Angers and the Hôtel d'Alluye at Blois (before 1508)), or further south at Toulouse.

The first architect to bring a more consciously classical style of architecture into France was Sebastiano Serlio (1475–1554), who arrived in 1540 or 1541. The house which he built for the Cardinal of Ferrara at Fontainebleau, called 'Le grand Ferrare', is now known only from

engravings, but it set a pattern, which was followed for more than a century, consisting of a principal *corps-de-logis* at the back of a courtyard which was flanked by lower wings and closed by a wall containing the main entrance. His only surviving building, the Château of Ancy-le-Franc near Tonnerre (*c.* 1546), is the first 'regular' building to be put up in France. It was not, however, much copied as a model, and Serlio's influence was exercised much more powerfully through his *Treatise*, which appeared in parts between 1537 and 1554, and which was used as a textbook by French architects for the remainder of the sixteenth century.

The formation of the School of Fontainebleau is an example of a phenomenon relatively common in the history of the visual arts, which for obvious reasons can hardly ever happen in the history of literature: a complete change of direction caused by the arrival of foreign artists. In literature the language barrier is inevitably so strong that the temptation to a poet to settle in another country is not great, and such emigrations usually only occur for external, probably political or religious, reasons.[1] Even the influence of foreign writers through their books, read in the original or in translation, has not quite the same immediacy as the physical presence of artists who set up their studios, take in pupils, execute commissions for patrons, and on occasion transform the art of the country of their adoption. Examples of such 'invasions' are not rare – Holbein and Van Dyck in England are obvious examples – though they hardly occur after the sixteenth century in France, but another aspect of the same phenomenon continued to be of importance. Till at any rate the beginning of the nineteenth century Italy – and above all Rome – continued to be the goal of every French artist, whether painter, sculptor, or architect, and all those who were able went there to study, either sent by a rich patron or, later, with a Prix de Rome. In this way they acquired a knowledge of Italian art which often exercised a decisive influence on their style. If they went to Rome, their principal aim would be to see the works of ancient art – which they studied just as writers read the classics – but they were also influenced by the art of Raphael or Annibale Carracci, or – more rarely – the great artists of the baroque, and they came back to France armed with drawings after the works they particularly admired, which they kept in their studios and to which they referred constantly as the standards at which they themselves aimed in their own productions. In

[1] The phenomenon occurs in music, but less frequently than in painting. The cases of Lully, Piccini and Gluck are the most obvious.

the later periods they were also kept in touch with what was taking place or had taken place abroad by means of engravings, which by the later seventeenth century had attained a high level of accuracy as reproductions. Finally, from the last years of Louis XIV's reign onwards, artists could see original works of older masters in the Royal Collection and in other private collections in Paris.

It must not be supposed that this constant reference to the works of ancient Roman or more recent Italian art implies any limitation in the French artists of the sixteenth and seventeenth centuries. On the contrary, what they learnt from their studies in Rome served only to enrich their minds and enabled them, if they had any innate imaginative power, to give richer and fuller expression to their own ideas. The history of French art at this time is largely that of the new and personal interpretation of ideas, formal and iconographical, learnt from the ancients or the great masters of the Renaissance. Poussin – the most personal and perhaps the most purely French of French classical artists – would have been the first to admit this. He declared himself the pupil of antiquity and Raphael, but no one would deny that he was one of the most original artists of the whole seventeenth century.

The way in which French artists of the mid-sixteenth century transformed what they had learnt from Italy into a national style is an example of this phenomenon. The transformation was due to two men: Pierre Lescot (1500/15–78) and Philibert de l'Orme (c. 1510–70). In the same year that Serlio planned Ancy-le-Franc, Lescot began work on rebuilding the Square Court of the Louvre, which replaced the medieval château. It was originally planned to be of about the same size as the medieval building, but at an early stage the project was enlarged so that each side of the court was to contain two wings of the original scale with a large central pavilion between them. Building proceeded very slowly, and the central feature which we see today, the Pavillon de l'Horloge, was built by Lemercier in about 1640. Lescot's style is a characteristically French variation on Italian models. Each floor is articulated by an order of half-columns, as would be normal in an Italian palace, but the treatment of architectural detail would to Italian eyes seem rather free, and the architect has indulged in a richness of surface decoration which would be unusual in Rome. This decoration was executed by the finest sculptor of the day, Jean Goujon (c. 1510–? 1568), whose work has an almost Hellenistic elegance. He also decorated the Hôtel Carnavalet, the only town house of the period surviving in Paris, which was almost certainly designed by Lescot,

and carved the exquisite reliefs on the Fontaine des Innocents (now in the Louvre).

Philibert de l'Orme was a much more inventive architect, who combined great skill in structure, derived from the tradition of medieval masons, with the use of classical forms which he learnt during a long stay in Rome. Little of his work survives, but the fragments of the château of Anet (begun c. 1549; the frontispiece has been moved to the École des Beaux-Arts, Paris) show his talents both as a builder and as a decorator. His treatise on architecture gives a remarkable insight into the way architects worked in the sixteenth century. De l'Orme was a friend of Rabelais, and the architectural details of the Abbaye de Thélème were probably supplied by him.

Art at the court of the last Valois, particularly Henri III, was of great, perhaps excessive, refinement. The paintings of Antoine Caron (c. 1520– c. 1600), who worked largely for Catherine de Medici, exaggerate the elongation of forms of the First School of Fontainebleau and go even further in the use of fantastic iconography, including references to alchemy and the most obscure ancient historians, all directed towards the flattery of the queen and her courtiers. The one great artist of the period was the sculptor Germain Pilon (before 1530–90), whose bronze figures from the tomb of the chancellor René de Birague (now in the Louvre) have a force and a vitality that set them apart from the other productions of the age.

The wars of religion limited activities in architecture and, though many great projects were produced, few of them got beyond the planning stage. Charles IX planned a vast château called Charleval, to rival the buildings of his father and grandfather; Catherine de Medici began the palace of the Tuileries and made plans for several large country châteaux, and a few courtiers imitated her; but little came of it and almost nothing remains. A few houses still stand in Paris, of which the most important is the Hôtel d'Angoulême, later the Hôtel de Lamoignon, built by a member of the Androuet du Cerceau family, which dominated the architecture of the time.

The Seventeenth Century

After the pacification of France, Henri IV quickly set about improving the city of Paris. His two great creations there, the Place Royale, now the Place des Vosges, and the Place Dauphine on the point of the Île de la Cité, are much in advance of town planning elsewhere and

embody Henri's desire to put up buildings of practical use to the citizens of Paris rather than monuments to his own glory.

During the reign of Henri IV painting was at a low ebb, and the painters employed by the king to decorate his palaces, who formed the Second School of Fontainebleau, were mainly of mediocre ability, though one, Toussaint Dubreuil (1561–1602), showed some sensibility. There was much more activity at the court of Lorraine, the art of which is best represented by the work of two etchers, Jacques Bellange (act. 1600–17), a Mannerist of unusual dramatic power, and Jacques Callot (1592–1635), who learnt his art in Florence but came back to Nancy for the last years of his life. His etchings range from witty renderings of court life to deeply felt records of the Thirty Years War, such as the *Grandes Misères de la Guerre* (1633).

In Paris much the most important event in painting in the early part of the century was the return in 1627 of Simon Vouet (1590–1649) from Italy, where he had spent some thirteen years, mainly in Rome. He brought back with him a knowledge of baroque painting as it was being developed in Rome by artists such as Giovanni Lanfranco and Pietro da Cortona. He soon established himself as the most popular painter with the king and with the great officers of the court, for whom he executed decorations for their châteaux and town houses, and altar-pieces for churches of which they were patrons. All the most important painters of the next generation – in the first instance Charles Lebrun – learnt their art in his studio. Vouet was not an artist of great originality, but he supplied French patrons with a form of moderate baroque style which exactly suited their needs. His paintings were striking and decorative, but they did not have the intense rhetorical emotionalism of Roman baroque art.

As *premier peintre du Roi* Vouet was the most powerfully placed artist in Paris, but both before and after his return from Rome there were other artists working in manners independent of his influence. Claude Vignon (1593–1670) had also spent some years (1616–24) in Rome, where he was influenced by Elsheimer and the Caravaggisti. His interest lay in richness of colour and texture rather than in the conventional formulas of the baroque. He was also influenced by the Dutch painters whom Rembrandt studied in his youth, and he was even in touch with Rembrandt himself, whose etchings he seems to have made known in Paris.

During the 1630s and 1640s there were certain painters who, though influenced by Vouet, yet moved away from his style towards a calmer,

more classical, manner. Of these the most attractive was Jacques Blanchard (1600–38), whose cool silvery tones contrast with the strong, sometimes rather brash colouring of Vouet. Laurent de la Hire (1606–56), who is said to have trained himself by the study of the painters of Fontainebleau, produced small paintings, mainly of religious subjects, which are markedly classical in style and in a sense prepared the Parisian public for the works of Poussin.

Other artists, notably Eustache Le Sueur (1616–55) and Sébastien Bourdon (1616–71), formed part of this classicizing group and were in their later works directly influenced by Poussin. Le Sueur was trained in Vouet's studio and for a time followed his style, but in his later works he was influenced by Poussin's religious painting of the 1640s. His series of canvases illustrating the life of St Bruno (Louvre), painted for the cloister of the Chartreux of Paris, have a quality of *recueillement* which is appropriate to the contemplative life of this order. Sébastien Bourdon spent some years in Rome, where he was influenced by the Dutch painters of popular scenes, called the *Bamb
occianti*, but on his return to Paris took up religious painting in a more personal style. The works of his last years are in a cold version of Poussin's classical style.

More independent were the three brothers Le Nain, who were born in Laon but spent their working lives in Paris, where they established a successful studio for painting large religious compositions. They are now, however, mainly remembered for their small naturalistic paintings of interiors, sometimes with groups of bourgeois sitters, sometimes with peasants. The eldest, Antoine (before 1600–48), painted very small pictures, sometimes on copper, of endearing simplicity but no great artistic merit. Mathieu, the youngest (1607–77), became a more fashionable artist and painted more polished groups, sometimes with figures from the Paris militia to which he belonged. By far the most distinguished is the middle brother, Louis (after 1600–48), whose paintings of peasants – sometimes in their kitchens, but sometimes in a landscape setting – have a classical dignity and detachment, avoiding the extremes of caricature or sentimentality which so often mark paintings of peasant subjects. It remains a mystery by whom these peasant groups were commissioned. There is no record of any collector owning a painting by any of the Le Nains till the 1760s, when, in the age of *sensibilité*, their works had a sudden success. It is unlikely that they painted for the great nobles or the very rich bourgeois because their works would be recorded in the inventories of their collections,

and it may be surmised – with every hesitation – that they worked for
real middle-class patrons, whose forebears may have come from the
country not many generations earlier. But this is a pure guess.

A less grand kind of naturalism is to be seen in the engravings of
Abraham Bosse (1602–76), which are of historical value as giving the
best available picture of everyday life in Paris in the mid-seventeenth
century, but which also have great technical skill and show a classical
sense of design.

The work of Bosse and the Le Nain brothers has analogies with the
naturalism of Dutch and Flemish art of the same period, but does not
seem to derive directly from it. Philippe de Champaigne (1602–70)
on the other hand was born in Flanders and partly trained there. He
came to Paris as a young man in 1621 and spent the rest of his life there.
Although he was originally trained as a landscape painter, his most
important works are religious compositions and portraits. In his earlier
years he was closely connected with the court and was commissioned
by the Queen Mother to paint a number of altar-pieces for convents
in which she was interested, notably the Carmelites of the Rue Saint-
Jacques, and he also executed official portraits for Louis XIII. His most
personal works were in a different vein and for different patrons. In
the early 1640s he came into contact with the Jansenists, and his outlook
on life and art was profoundly influenced by their teachings. His
daughter became a nun at Port-Royal and Philippe himself remained
in close touch with the group, painting the altar-piece for the abbey
and portraits of many prominent Jansenists. Some of these are portraits
from life – Arnauld d'Andilly, La Mère Agnès Arnauld – but others were
certainly commemorative portraits, executed at or after the death of
the subjects. They were images of the saints of Jansenism – Jansen him-
self, the first Saint-Cyran, and others – and it is certainly no chance that
they have a remarkable similarity to the *chef* reliquaries made in the
Middle Ages to house the relics of particularly venerable saints.
Champaigne's grandest expression of his devotion to Jansenism is the
portrait of La Mère Agnès Arnauld and Champaigne's own daughter,
painted to celebrate the miraculous cure of the latter brought about in
1662 by the prayers of the nuns of Port-Royal. It is perhaps the calmest
and most classical rendering of a miracle in seventeenth-century art.

Paris was the main centre of artistic activity in France at this time,
but in centres such as Toulouse and Aix-en-Provence there existed
schools which were to some extent independent of the capital. Most
of these were undistinguished, but Nancy produced one great artist in

Georges de la Tour (1593–1652), who gave to the naturalism and the dramatic use of light which had been the great innovation of Caravaggio a monumentality and a stillness which have justifiably led to the word 'classical' being applied to his art.

It is a paradox that the two greatest French painters of the seventeenth century spent their whole working lives in Rome. Nicolas Poussin (1594–1665) was born in Normandy and spent his youth in Paris, but in 1624 he settled in Rome, only leaving it for an unhappy visit to Paris in 1640–2. Claude Gellée, Le Lorrain (1600–82), was born in Lorraine but went to Rome as a boy, staying there for the rest of his life, apart from a visit to Nancy in 1625.

Poussin arrived in Rome at the moment when the baroque style was reaching a sudden maturity, but, except in one or two early experimental works, he set his face against this movement and, working outside the mainstream of official painting in Rome, evolved a style which is among the purest expressions of the classical spirit. From his first years in Rome his approach to his art was deeply influenced by the circle of friends among whom he moved and for whom he worked. This was centred round Cassiano dal Pozzo, a patron of the arts, a passionate admirer of antiquity, a learned archaeologist, and a student of both philosophy and the natural sciences. From Pozzo and his friends Poussin soon acquired a knowledge not only of ancient art, but also of ancient history and philosophy, which was to be a vital factor in his artistic creation. Poussin is one of the rare instances of an artist who painted primarily to express his ideas, but he believed that the idea must be expressed in a form which is beautiful in itself and perfectly suited to it. It was to the pursuit of this ideal that he devoted his life, avoiding public acclaim in order to work quietly in his own studio, rejecting the tricks and virtuosity of his baroque contemporaries, and seeking only to satisfy his own scrupulous sensibility.

During the late twenties and the first half of the thirties his themes were chosen mainly from Greek and Roman mythology, above all from Ovid's *Metamorphoses*, and these he embodied in a series of small poetical canvases, warm in colour and free in handling, in a style inspired by the *Bacchanals* of Titian, which he studied and even copied in Rome. These early paintings appeal immediately by their atmosphere and their technical brilliance, but they generally have more complex associations than appears at first sight. The *Arcadian Shepherds* (Chatsworth) is an allegory on the frailty of human happiness, and many of the mythological paintings were almost certainly intended to have

allusions to the cyclical processes of nature, particularly the alternation of day and night, and some, such as the *Death of Adonis* (Caen), refer to familiar ancient symbols of death and resurrection.

In the second half of the thirties Poussin's work began to be known in Paris. Cardinal Richelieu commissioned two famous *Bacchanals* for the Château de Richelieu, but Poussin's main patrons in France were drawn from a group of serious though not very wealthy bourgeois civil servants, small bankers, silk manufacturers, and so on, some of whom visited Rome and were in contact with the circle of Pozzo. It was for them that Poussin produced in the 1640s and early 1650s the paintings for which he was most famous in his own day and for the remainder of the seventeenth century.

The themes of these paintings were drawn mainly from the *Lives* of Plutarch or from the New Testament. Poussin's letters make it abundantly clear that he was a keen admirer of Stoic philosophy – indeed his own life was lived in accordance with it – and he found inspiration for some of his finest works in the stories of Phocion, Scipio Africanus and other heroes of Plutarch. On the other hand he was a sincere Christian, sometimes making light of the outward ceremonies of the Church of Rome, but believing profoundly in her basic doctrines. But, as was often the case in the seventeenth century, there was no conflict between his two creeds, and in some of his most remarkable works of this period, notably the *Seven Sacraments* (Duke of Sutherland collection, on loan to the National Gallery of Scotland), the two are combined in a kind of syncretism not uncommon at the time.

Stylistically there is a marked change in these works. Poussin now conceives of painting as a rational art, appealing to the mind, not the eye, and he jettisons all the sensuous attractions of his earlier work in his pursuit of the clearest, most explicit, and most concentrated expression of his theme. Forms are sharp and moulded like Roman sculpture; colours are clear and unbroken; space is defined with the utmost clarity; gestures are used solely to express the action and emotion of the participants in the scene; architecture and other archaeological details are minutely thought out. The result is an art without surprises, but with rare lucidity and harmony.

In the same period Poussin developed his interest in landscape painting, usually as a setting for a Stoic story, such as that of Phocion (two paintings, belonging to the Earl of Derby and the Earl of Plymouth). Here the figures are relatively small and nature plays the major role, but it is an orderly nature, drawn to the scale of man,

and it is almost certain that Poussin had in mind the Stoic idea that the greatest manifestations of the λόγος were the harmony of nature and the virtues of man. In his last years Poussin's landscapes change in character: nature becomes rich, luxuriant and powerful, and man becomes a worm. The almost pantheistic feeling in these paintings was apparently inspired by the doctrines of Tommaso Campanella, but Poussin also incorporates in them certain mythological themes which had been used by late antique Stoic philosophers, such as Macrobius, as allegories for the processes of nature. Poussin therefore returns to themes which he had treated in his youth, but he does so in a very different spirit. The last paintings, such as the *Apollo and Daphne* (Louvre), are the meditation of an ageing philosopher, not the romantic out-pourings of a young painter; they carry one to a world of intellectual dreaming, in which Poussin's ideas find their purest and most poetic expression.

Claude Lorrain is in many respects the exact opposite of Poussin. He only painted landscapes and never figure compositions. Poussin sprang from the tradition of ancient art and of Italian High Renaissance painting; Claude belongs to the line of naturalist landscape painters from Flanders, Holland and Germany who worked in Rome. Even in their treatment of landscape painting their approaches are different. Poussin's landscapes are closed and rationally ordered; Claude's are open to the horizon and evocative. They recall the beauty of the Campagna round Rome, which was usually the subject of his landscapes; but they do not evoke it only visually; they call up the legends which had grown up in it, the nymphs and country deities who haunted it in Virgil and still haunt it today, the stories of Aeneas sailing up the Tiber and landing at Pallanteum to found the city of Rome. Sometimes Claude paints religious subjects or themes from Ovid, but these, too, he sets in the Campagna. Claude loved the sun and the sea. No painter has suggested so vividly the ripples of the Mediterranean disappearing towards the horizon, and no painter before him had had the courage actually to paint the sun in the sky.

Claude's landscapes show us a quintessence of the Campagna in generalized form, but they are based on a minute study of the actual scenery which he painted. His drawings are unequalled for their subtle observation of the silhouettes formed by trees against the sky and of the effects of light, direct or *à contre-jour*, which he observed in the Campagna. His early biographers tell us that he went out before dawn to draw and often lingered till sunset, and many of his paintings

embody his observation of the long shadows of early morning and late evening, and sometimes even of the effects of moonlight. The Dutch painters of Claude's time observed nature with as much care as he did, but their approach was more prosaic. He penetrated more deeply into the spirit of nature, and it is no chance that he was so much admired by the Romantic poets. His paintings have much in common with the poetry of Keats, who wrote a very moving description of one of them, the *Enchanted Castle* (C. Loyd collection, Lockinge, Berkshire).

The middle decades of the seventeenth century were also a period of great glory in French architecture. The movement begins with Salomon de Brosse (1571–1626), who, though trained in the school of the Androuet du Cerceau family, rejected their ornate and tortured style and brought French architecture back to the line of classicism inaugurated by Philibert de l'Orme. Much of his work has been destroyed, but the Luxembourg Palace, built for Marie de' Medici (begun 1615), and the façade of the Palais du Parlement de Bretagne at Rennes (now the Palais de Justice) reveal a feeling for simple masses which had been lost in the late sixteenth century in the pursuit of surface ornament.

The most successful architect of the next generation was Jacques Le Mercier (1585–1654), who, after a period of training in Rome, became first architect to the king and, what was even more important, the favourite architect of Cardinal Richelieu, for whom he built the châteaux at Richelieu and Rueil, the Palais Royal and the Sorbonne. Of these works only the church of the Sorbonne survives and shows Le Mercier to have been a competent but unimaginative architect. The true successor to Salomon de Brosse was François Mansart (1598–1667). He created the first maturely classical style of French architecture and, in the subtlety of his interpretation of antiquity, as well as the refinement of his designs, he forms a close parallel to Poussin. In spite of the fact that he almost certainly never visited Italy, his works reveal a far truer understanding of the architecture of the Italian Renaissance than those of Le Mercier, who spent many years in Rome.

Like Poussin, Mansart worked mainly for the bourgeoisie rather than the great noble families, but, architecture being a more expensive art than painting, it was among the very rich members of the class that he found his patrons. They were often the rich *partisans* who had made their fortunes through the exploitation of the State taxes, or the most powerful - and probably most corrupt - members of the legal caste,

but they had the taste to appreciate his art and the patience to put up with his arrogant and wayward character.

In his earliest surviving work, the Château de Balleroy, near Bayeux, Mansart breaks with the French tradition of building châteaux round a central courtyard and creates a free-standing block divided into three harmoniously related sections. In this he was following the example set by de Brosse in the destroyed Château of Blérancourt, but in his two major works of this kind, the Orléans wing of the Château de Blois (1635–8) and the château of Maisons, now Maisons-Laffitte (1642–6), near Paris, he goes far beyond his master.

At Blois the effect depends mainly on the scrupulous manner in which he respects the surface of the walls, only broken by light pilasters, which are carefully disposed so as not to interfere with the sharpness of the corners which define the blocks. At Maisons the main block is broken up in a much bolder manner, leading in a series of stages to the tall central frontispiece, composed of three superimposed groups of coupled columns, each floor being treated in a different manner. The effect of variety is increased by the presence of two one-storeyed wings which project at each end of the block. Inside the château the most remarkable feature is the staircase, one of the first to be built in France round an open well, so disposed that the spectator can grasp at a single glance the whole space and the movement of the staircase itself. The detail at Maisons is of superb quality. The orders are treated with a correctness hitherto unknown in France; some of the carved decoration, which was executed by Jacques Sarrazin (1588–1660) and the brothers François (1604–69) and Michel Anguier (1617–86), foreshadows the classicism of the style of Louis XVI; and the wrought-iron grilles, which originally filled the entrance doors but are now in the Galerie d'Apollon in the Louvre, show an incredibly high level of craftsmanship.

Although Mansart was essentially a great classical architect, there are certain features in his work which come close to the baroque. At Maisons he used concave oval bays on the outside of the projecting wings, and even more complex shapes occur in his designs for the east front of the Louvre. Moreover, if his whole schemes for Blois and Maisons had been carried out, they would have created enormous vistas of a kind which are characteristic of the baroque: at Blois a great forecourt leading down into the town on one side, and, on the other, gardens carried on a huge bridge over the ravine behind the château; at Maisons long avenues leading at right angles to each other into the

Forêt de Saint-Germain. Here and in the Château of Fresnes, near Meaux – now destroyed – Mansart also used many forms of garden layout the invention of which is generally attributed to André Le Nôtre.

Mansart was also involved in the building of several churches, but many of them have been modified or destroyed. The Visitation in the Rue Saint-Antoine is an early work, ingenious in plan and decoration, but unfortunately the Val-de-Grâce, which would have been his master-piece, was not completed according to his designs. The plan is his, and he carried the actual building up to the level of the cornice; but the commission was then taken away from him and given to Le Mercier, on account of Mansart's extravagance and his refusal to stick to any plan he had made if he thought of an improvement to it. This difficult temperament caused him also to lose the commission for the east wing of the Louvre, and probably also prevented him from carrying out the chapel which Louis XIV planned to build at the east end of Saint Denis to form a mausoleum for the Bourbon dynasty, grander than the Valois chapel begun by Catherine de Medici for her husband, herself and their children, attached to the transept of the same church.

The third architect of this group, Louis Le Vau (1612–70), was a younger man and leads over into the period of Versailles. He began his career as a brilliant designer of town houses, and the Hôtel Lambert, on the point of the Île Saint-Louis (begun 1640), is one of the best examples of ingenuity in the exploitation of a difficult site. His great opportunity came when he was commissioned by Fouquet to build the Château of Vaux-le-Vicomte, near Melun. The château it-self lacks the *finesse* of Maisons, and the great achievement of Fouquet and Le Vau was the organization of a team of artists of all kinds to collaborate in a great whole, including the gardens as well as the house, sculpture and painting as well as architecture, and even the art of music. The team only gave one full performance, the great fête of 17 August 1661, given by Fouquet to the king, which precipitated the Minister's downfall. Here, in a château designed by Le Vau and painted by Charles Lebrun, set in gardens designed by Le Nôtre with sculptures after models by Poussin, the first performance of Molière's *Les Fâcheux* was given, with a prologue by La Fontaine and interludes by Lully. When Fouquet was arrested, Colbert had only to take over this team to serve the king and prepare the art of Versailles.

The Personal Reign of Louis XIV

Louis XIV did not finally decide to abandon the Louvre in favour of Versailles till about 1668, and during the 1660s Colbert, who was still hoping to persuade the king to remain in Paris, was concerned with the completion of the Square Court of the Louvre by adding the east wing which was to contain the principal entrance to the palace. After Mansart's designs had been rejected, the king asked various Italian architects to submit designs and eventually invited Bernini to come to Paris to supervise the actual execution of the building. For various reasons – not least the fact that Bernini took no account of French taste or the requirements of the king – the project was abandoned, and the designs are now known only from engravings. The event was of great significance as symbolizing the fact that France was no longer subservient to the dictates of Rome in matters of taste, but was establishing its own standards and indeed preparing to create a style which was to dominate Europe. This style was fully elaborated only at Versailles, but many of its essential features are to be seen in works executed on Colbert's orders at the Louvre: the Galerie d'Apollon, redecorated by Le Vau after a fire in 1661, and the Colonnade, built between 1667 and 1670 after designs for which Le Vau was mainly responsible.[1]

French art of the period from 1661 till the death of Colbert in 1683 is dominated by two factors: the taste of the king – and more particularly his ideas on the function of the arts in an absolute monarchy – and the ability of Colbert and Lebrun (1619–90) to give these ideas practical expression. For Louis XIV the main function of the arts was to provide an appropriate setting for his person and his court and to record his actions and the glories of his reign. For this purpose the team of artists taken over from Fouquet formed an admirable starting-point, but a clear formal organization was needed. This was achieved by two means: the reorganization of the Academy and the creation of the Gobelins. The Académie de Peinture et de Sculpture had been formed in 1648 by a group of artists under the protection of the Chancellor, Séguier, primarily to free themselves from the old *maîtrise*, the Guild of St Luke, which was in many ways out of date and restrictive. In 1663 Lebrun was put in charge of the Academy and undertook a complete reform

[1] The design was theoretically produced by a committee of three – Le Vau, Lebrun and Claude Perrault – and controversy has raged since the seventeenth century about the shares of the three artists, but the evidence seems to point to Le Vau as the principal inventor.

of its organization. Its function was double: to train young painters and sculptors, and to define the correct doctrine about the arts, just as the Académie Française was responsible for the principles of language and literature. The training was carefully organized under a team of professors, who were also compelled, often against their will, to give lectures on individual paintings in the Royal Collection, in which they laid down the principles according to which artists should work. The Gobelins was designed to fulfil a more practical function. Under the direction of Lebrun a superb group of craftsmen was brought together who could design and execute everything that was necessary for the decoration of a palace: furniture, wood-carving, tapestry, and silver-work. Only carpets were excluded, and they were made in a separate factory at the Savonnerie. For all these works Lebrun supplied at least small sketches, which were worked up and then put into execution by the individual craftsmen.

Versailles had originally been a small château built by Louis XIII as a hunting lodge, and when Louis XIV decided to make it the seat of the court and the centre of the State administration, drastic enlargements were necessary. The first alterations, begun by Le Vau in 1669, involved building two flights of rooms on the outside of the existing château, one for the king's *appartement*, the other for the queen's. These ended on the garden front in two pavilions, between which ran a terrace at first-floor level. At the end of the 1670s the king decided to fill in this terrace, in order to build the Galerie des Glaces, the Salon de la Paix, and the Salon de la Guerre. Soon afterwards the palace was extended by the addition of two long wings, which gave the garden façade a length of more than 1,800 feet. Le Vau had died in 1670, and the alterations were carried out by Jules Hardouin-Mansart (1646–1708), the great-nephew of François Mansart, who exercised supreme power over the royal buildings for more than thirty years. Unfortunately he did not take into account the effect which the vast increase in length would have on the façade as a whole, and he simply repeated Le Vau's design with a small order for the principal floor, which was in scale with the original front but has a certain meanness when repeated over the central part of the façade, no longer broken by the terrace, and the whole length of the wings.

The two *Grands Appartements* are the most magnificent manifestation of the art of Louis XIV's reign; or, it would be truer to say, they were such a manifestation at the time of their creation, because many of their essential elements have vanished. The marbled panels of the walls,

the stuccoed and painted ceilings, and the carved doors survive, but the marble floors were taken up after a short time for practical reasons, many of the tapestries were sold and – the greatest loss of all – the silver furniture was all sent to the mint to be melted down in 1689 during the war of the League of Augsburg. Unhappily there are no adequate visual records of what these rooms looked like when completely furnished, and it requires a considerable effort of the imagination to visualize their splendour.

The gardens of Versailles are as splendid as the palace. Here Le Nôtre, who had developed the new style of garden design on a small scale at Vaux and the Tuileries, had the opportunity of working in the grand manner and to lay out a complex of parterres, *allées* and canals, punctuated by sculptures and fountains, on a scale hitherto unknown. To twentieth-century eyes the gardens of Versailles seem formal, but in fact Le Nôtre's object was to break away from the even more artificial Italian type of garden, which was composed mainly of pergolas and knot-gardens, and to make his park more 'natural'.

Lebrun was in the first place a superb organizer, but he was also a fine artist in his own right. He was something of a prodigy and was already providing mature works of considerable originality and great force before he went to complete his studies in Rome in 1643 at the age of twenty-four. In the execution of the painted ceilings at Versailles and the huge canvases commissioned by the king, such as the *Histoire d'Alexandre*, he of necessity made use of assistants, but evidently executed much of the work with his own hand. His real talents as an artist appear at their best in a small group of very moving works, painted for his own pleasure during the years after the death of Colbert, when he was in effect pushed aside by Louvois and prevented from obtaining any official commissions.

The Academy laid down strict rules for the teaching of its students. The young painter began by copying, first from engravings or drawings and then after paintings by the accepted masters, and finally from casts of ancient sculpture. By this process he was supposed to learn what was beautiful in nature, according to the accepted standards, which meant in effect according to the practice of the ancient Romans, Raphael and Poussin. Only after he had fixed in his mind the principles according to which these artists worked, above all in so far as they concerned the proportions of the human figure, was the young artist allowed to draw directly from nature, for only then would he be in a position to judge what was truly beautiful in nature, what was in

accordance with the ideal which, according to Aristotle, nature always seeks but never attains in any one work. Lebrun also laid great stress on the importance of the correct expression of the emotions, and in his treatise on the subject laid down rules on how the features of the face were affected by different emotions, examining the physiological causes for the changes and further investigating the analogies which exist between the various types of human face and the heads of different animals.

The doctrine of the Academy, based as it was on the models of antiquity, Raphael and Poussin, further laid down that drawing was the true basis of painting, because it appealed to the mind, and that colour, which only appealed to the eye, was of altogether minor importance. This doctrine soon aroused opposition and led to a series of violent discussions between the supporters of drawing, called the *Poussinistes*, and the partisans of colour, called the *Rubénistes*, because they set up Rubens as the equal of the great French painter on account of his mastery of colour. The drawing–colour quarrel was in many ways a parallel to the Quarrel of the Ancients and Moderns, in that it involved a challenge to the supremacy of ancient sculpture and of the masters who based their art on the study of it. It was also connected with a new naturalism in painting, because one of the arguments in favour of colour was that it produced a more complete imitation of natural objects than was possible by drawing alone. In the end the supporters of colour, led by the critic Roger de Piles, won the day, and the tradition of classical idealism inaugurated by Poussin and carried on by Lebrun and the Academy gave way to a quite different conception of painting.

This change was to have its most important effects in the early eighteenth century on painting not directly connected with the king, but even the art of Versailles underwent changes in the last decades of Louis XIV's reign. In painting a more baroque spirit and a stronger feeling for colour appeared in the work of Charles de la Fosse (1626–1716), who executed some paintings for Versailles and decorated the dome of the Invalides in an illusionistic baroque idiom. This tendency was even more marked in the work of Antoine Coypel (1661–1722), for instance in the vault of the chapel at Versailles, but the most brilliant ceiling painting of this transitional period is that of the Salon d'Hercule, also at Versailles (1733–36), by François Lemoyne (1688–1737), in which the artist gives up the heavy illusionist architecture introduced by earlier decorators and opens up the whole ceiling to the sky, producing an effect which can almost be called rococo.

In portraiture artists began to break away from the old formality of Pierre Mignard (1612–95), and in the hands of Hyacinthe Rigaud (1659–1743) and Nicolas Largillierre (1656–1746) the art took on a new vigour and a new naturalism, partly derived from the study of Dutch and Flemish models. At the same time a certain lightness appears in the paintings commissioned by the king for the Grand Trianon and for some smaller buildings at Versailles, such as the Ménagerie, which was decorated for the Duchesse de Bourgogne. The grandeur and formality of the previous phase disappears, and in some respects these paintings prepare the way for the rococo.

Other tendencies, not directly connected with the court and partly inspired by the art of the Low Countries, led in the same direction. The Academy had laid down a strict hierarchy of the arts, headed by history painting, which included mythological and religious subjects as well as historical themes in the normal sense, and with the other genres – portraits, battles, domestic scenes, landscape, animal painting, and still life – in lower positions in descending order of importance. The claim of the *Rubénistes*, that the imitation of natural appearances was the first object of painting, led naturally to less emphasis being laid on the *sujet noble*, and the minor genres rose to a higher status. The change can be traced in the lists of paintings shown at the Salon, which was inaugurated in 1673 and held very irregularly till the 1730s. In the early Salons almost all the paintings would have been classed as 'history', but in 1704 the balance had changed so much that there were more pictures of domestic scenes and still lifes than of religious or historical subjects. Animal painting had always held a certain importance at the court, where François Desportes (1661–1740) and later Jean-Baptiste Oudry (1686–1755) were commissioned to paint the king's dogs and the animals in the Ménagerie; Adam Frans van der Meulen (1632–90) had been employed to paint the campaigns of the reign; and flower paintings had been used as decorations for overdoors in the royal palaces; but now all the minor genres became popular with the public and were treated in a much more naturalistic spirit.

The painting of battle-scenes was transformed by Joseph Parrocel (1646–1704), who learnt his art in Venice instead of Rome, and whose use of colour has the richness and brilliance of Delacroix. Equally striking examples of the change in taste are the landscape studies of Desportes (mainly in the Château de Compiègne), made primarily for his own enjoyment, which foreshadow the early sketches of Corot in

their direct and sensitive rendering of the countryside of the Île-de-France. In the early years of the eighteenth century Claude Gillot (1673–1732) revived an aspect of the art of Callot in his drawings and paintings of the Italian Comedy. At the same time artists and collectors turned their attention to the Flemish and Dutch schools. The Duc de Richelieu had brought together a magnificent group of paintings by Rubens, which incited Frenchmen to look – curiously enough almost for the first time – at the series of canvases which he had painted in the Luxembourg Palace for Marie de' Medici. Rembrandt, too, was 'discovered' by artists such as Rigaud, who owned several canvases by him and imitated him in style in his rare religious compositions.

Sculpture went through similar changes. The art of François Girardon (1628–1715), who had been the principal designer of the sculpture which ornamented the gardens at Versailles and had made portraits of the king and his courtiers in a formal classical style, gave way to the livelier manner of Antoine Coysevox (1640–1720), who was capable of baroque swagger in his official portraits, of penetrating psychological observation in busts of his friends, and of a near-rococo lightness and elegance in his portrayals of the Duchesse de Bourgogne (Louvre). Pierre Puget (1620–94), who was born in Aix-en-Provence and worked mainly in Genoa, Toulon and Marseille, enjoyed a sudden burst of favour after the death of Colbert, when his almost purely baroque groups, such as the Milo of Crotona (Louvre), were placed in the gardens at Versailles; but his style was too strong meat for the court, and after a short time his contact with Versailles ceased and he continued to work for patrons in his native Provence.

In architecture there is a marked change in the buildings designed for the king by Hardouin-Mansart, of which the most important are the chapel at Versailles and the new church of the Invalides. The first (begun in 1688 but not finished till 1710) is a brilliant solution to the problem presented by the designing of a court chapel, in which the emphasis has to be as much on the royal gallery at the west end on the first floor as on the altar on the lower floor at the east, but it was criticized at the time for its unusually high proportions, which were said to be 'Gothic', and indeed from the outside the apse, with its buttresses and its high-pitched roof, looks almost like the *chevet* of a Gothic cathedral. The Église du Dôme at the Invalides (1676–91), though partly based on François Mansart's designs for the Bourbon Chapel at Saint-Denis, is one of the most explicitly baroque buildings put up in France in the seventeenth century, particularly in the treatment of the

dome, which internally is cut off, so that the eye passes through to La Fosse's fresco of St Louis received into heaven, lit by windows concealed by the lower dome. There is some reason to think that Louis XIV originally planned this church as a mausoleum for himself and his family, but, if this is so, the project was altered and no tomb was erected till the ashes of Napoleon were enshrined there in the nineteenth century.

At the same time domestic architecture was also moving away from the formal classicism of the 1670s and 1680s, but in a different direction. The new style is first visible in certain rooms at Versailles and the Grand Trianon, remodelled in about 1700. In these rooms the decoration becomes lighter; pilasters are no longer used; cornices take on more broken forms, and looking-glasses with slender frames replace the traditional heavy overmantels.

The Eighteenth Century

The changes which took place in painting, sculpture and architecture in the years around 1700 led up to the rococo, the style which dominated French art roughly between 1715 and 1750.[1] The origin of the style has often been connected with a reaction against the formality of Versailles which followed the death of Louis XIV and, although this is an over-simplification, since many of the crucial steps towards the rococo were taken at Versailles, it is true that in its early phase the rococo was often connected with Paris, which at this period began once more to assert its independence of the court in matters of taste as well as in politics. It was the period when the Faubourg Saint-Germain was being developed as a residential centre by the nobility and by the newly enriched bourgeoisie, who built there a series of *hôtels* which represent one of the high points in domestic architecture. Owing to the fact that there was more space than in the crowded quarters of the old city, architects were able to make their buildings spread horizontally, and the traditional arrangement with the house built in three or four storeys round a relatively small court was replaced by a plan with the main *corps-de-logis* spread along a wide façade of two or sometimes only one floor, while at the back a large garden provided space and air

[1] The style is usually called by French writers 'le style Louis XV', in spite of the fact that it originated before the death of Louis XIV and was well developed under the Regency. In the same way most of the elements which make up the transitional style called 'Style Régence' were invented before 1700 by artists such as Jean Bérain (1640–1711) and Daniel Marot (1663–1752).

on a scale unknown in earlier houses. The rooms were planned in a much more convenient manner than previously. For the first time a special room was set aside as a dining-room, and attention was paid to the advantages of having the kitchen near it rather than on the other side of the court. The bedroom, which under Louis XIV had been the scene of all formal functions, now became a private room for the use of the owner of the house, and a series of *salons* and *boudoirs* were included to be used for formal or intimate occasions. The rooms are now often circular or oval in shape, and these forms are varied by the addition of curved niches or alcoves. The decoration takes on a lightness and an elegance in harmony with these new ideas of intimacy and convenience. The old system of ceilings with a mixture of stucco and painted decoration and walls divided into panels by an order of pilasters vanishes, and the whole room is decorated with a light network of curvilinear patterns which play across the flat or slightly curved ceiling and over the doors and walls in a low relief which hardly interrupts the plane surfaces. Generally the walls were panelled in oak or pine, usually painted white picked out in gold, and the ceiling was decorated in stucco of the same colours. Sometimes, however, the wall panels were painted with flowers, grotesques, or *singeries*, and occasionally paintings were introduced as overdoors. The decoration of the room was completed by looking-glasses, crystal chandeliers, and furniture, often inlaid and ornamented with ormolu, on which would be displayed porcelain imported from the Far East, known as *Compagnie des Indes* from the organization through which it reached Europe.

In this period there was no one figure who dominated architecture as Hardouin-Mansart had done in the previous phase, and these exquisite ensembles were created by a group of talented architects who had mostly received their training in his office, the best known being Robert de Cotte (1656–1735), who decorated the Galerie Dorée at the Hôtel de Toulouse (now the Banque de France) in 1714–15; Pierre Cailleteau, called L'Assurance (1655–1723) and Germain Boffrand (1667–1754), who was responsible for the two oval *salons* at the Hôtel de Soubise (now the Archives Nationales; 1735–6).

In painting the period produced one artist of genius, Antoine Watteau (1684–1721), who died of consumption at the age of thirty-seven. He was born and partly trained in Valenciennes, a town which had only recently become French and was still dominated by its cultural affiliation to Flanders, and his early style was largely formed by the study of Flemish genre painters, such as the younger Teniers. When he

came to Paris at the age of eighteen, he joined the studio of Gillot and learnt from him a witty style of draughtsmanship and an interest in painting fancy subjects connected with the theatre. In Paris he saw and studied the paintings of Rubens and the Venetians, which transformed his approach towards the use of colour. From these elements he composed a style of almost unparalleled elegance and delicacy, combining a crisp and witty touch in drawing with an almost romantic treatment of landscape. His subjects were mainly *fêtes galantes*, or scenes enacted by the people of his own time but in a fancy dress which owed something to the theatre and something to the traditions of the pastoral. In the greatest of these, the *Embarquement pour Cythère* (Louvre), he also incorporated a type of love-allegory which goes back to the *Carte de Tendre* and the tradition of the Hôtel de Rambouillet. The *fête galante* became fashionable with the rich financiers for whom Watteau worked – the most sympathetic were the younger Crozat and Jean de Julienne, who looked after the artist in his last illness – and Watteau had many imitators, such as Nicolas Lancret (1690–1743) and Jean-Baptiste Pater (1695–1736), but they never attained the same imaginative level as Watteau. They were brilliant *virtuosi* who turned out their works in an almost mechanical manner; he was an artist of deep feeling and of penetrating observation. Particularly in his drawings, but also in his paintings, he can make the turn of a head or the gesture of a hand express something of deep significance which creates a mood rare in eighteenth-century painting. The poetical power of his art is seen at its most noble in the life-size painting of *Gilles* in the Louvre, and at the other extreme his naturalism and his sense of design enabled him to paint the *Enseigne de Gersaint* (Dahlem Museum, Berlin), a monumental record of a contemporary scene; but these are exceptions, and Watteau will always be regarded as the creator of the lyrical paintings of the *fêtes galantes*, which sum up in quintessential form the culture of early eighteenth-century Paris, recorded with almost equal sensibility in the comedies of Marivaux.

A second stage of rococo painting is represented by François Boucher (1703–70), a brilliant performer, but altogether lacking the profundity of Watteau. He replaced the *fête galante* by the *bergerie*, a much more artificial genre, in which the erotic element is more marked than in the painting of the previous generation. It could be argued that Boucher was at his best in portraiture, and his small full-length of Madame de Pompadour (Wallace Collection) sums up to perfection the mannered elegance of the mid-century, better in fact than the work of the

professional portrait painter of the period, Jean-Marc Nattier (1685–1766), in whose paintings the character of the sitter is lost in the pink waxen complexion and the brilliance of silks and laces. A far finer observer of character was Maurice Quentin de la Tour (1704–88), whose portraits record not only the ladies of the court, but with magnificent penetration the intellectuals (Voltaire, Diderot), the actresses (Mademoiselle Fels) and, even more movingly, his own plain but lively face. The third portrait painter of the time, Jean-Baptiste Perronneau (1715–83), was particularly successful in the depiction of older women. His portraits are somewhat akin in their dignity and also in their technique to the works of Gainsborough.

The delicate art of the rococo was not suited to large-scale works or to stone as a medium, and it is therefore not surprising that little monumental sculpture of importance was produced in France during the first half of the eighteenth century. The most notable exceptions were the Chevaux de Marly (1740–45) by Guillaume Coustou (1677–1746), which now stand at the entrance to the Champs Élysées, and Robert le Lorrain's (1666–1743) relief of the horses of Apollo over the stables of the Hôtel de Rohan (1740), a brilliant example of low-relief decoration on architecture. Jean-Baptiste Lemoyne (1704–78) made a series of portraits, mainly equestrian, of Louis XV for the great provincial towns of France. These were all destroyed in the Revolution, but some are known from small bronze versions. The most baroque artists of the middle of the century were Jean-Baptiste Pigalle (1714–85), whose famous statue of Voltaire in the nude is in the Institut de France, and Étienne-Maurice Falconet (1716–91), who designed the impressive equestrian statue of Peter the Great, commissioned in 1766 by Catherine the Great for St Petersburg.

Falconet's other works illustrate the taste for small delicate statuettes, which was characteristic of the mid-century, particularly of Madame de Pompadour, who, appropriately, made Falconet head of the Sèvres porcelain factory. Claude Michel, called Clodion (1738–1814), specialized in small terracotta figures in the same vein. Perhaps the greatest achievement of the age in sculpture lay in portraiture. Almost all the artists mentioned above executed fine work in this genre, but it reached its greatest height towards the end of the century with the busts of Augustin Pajou (1730–1809) and Jean-Antoine Houdon (1741–1828), who portrayed all the great men of their day – Voltaire, Rousseau, Diderot and even Washington – with brilliant observation of features and pose.

The elegance of the period is reflected in the elaborately veneered and inlaid furniture associated with the reign of Louis XV, of which the greatest master was Charles Cressent (1685–1768), the Gobelins and Beauvais tapestries after the designs of Boucher and Jean-François de Troy (1679–1752), the fine carpets from the Aubusson factory, and the products of the china factories of Vincennes and Sèvres.

Neoclassicism and Romanticism

About the middle of the eighteenth century a change began to be evident in all the arts. Artists and patrons began to react against the frivolity of the rococo and turn to more serious subjects and more restrained forms. A new style was born, known as *le style Louis XVI*, because, although it was created well before the death of Louis XV, it dominated the whole reign of his successor.

The change was partly due to the more serious atmosphere which prevailed in intellectual circles in France under the influence of the *Encyclopédistes*, but in the arts it was directly sponsored by the Marquis de Marigny, brother of Madame de Pompadour, who was appointed Surintendant des Bâtiments in succession to his uncle, Lenormont de Tournehem, in 1751. Marigny's artistic education had been furthered by a long visit to Italy which Madame de Pompadour had arranged for him in 1749, accompanied by the engraver Nicolas Cochin, the architect Soufflot, and the Abbé Leblanc. This visit was carefully planned to enable Marigny to see the great works of ancient art, first in Rome and then in the paintings and sculpture newly excavated at Herculaneum and Pompeii. He came back inspired with enthusiasm for the grandeur of ancient Rome and for the ideals of classical art.

On his return he set about transforming the organization of the arts in France. In painting and sculpture he established a series of competitions with set subjects drawn from history, that is to say, the kind of noble subjects which had been normal in the later seventeenth century but which had been almost entirely displaced by semi-erotic mythological themes and *bergeries* in the first half of the eighteenth century.

The change of subject in painting was accompanied by a change in style, which also affected the painting of religious and domestic subjects. The contrast between the old and new manners is admirably brought out by Diderot in his *Salon* of 1767, in which he makes a detailed comparison between the *Miracle des Ardents* by François Doyen (1726–1806)

and the *St Denis prêchant la foi* by Joseph-Marie Vien (1716–1809), both painted for the church of St Roch, the former a bombastic baroque *grande machine*, full of ecstatic figures, putti, and clouds, the latter a calm, carefully thought-out composition in which each figure plays a specific role, carefully made intelligible by his gestures and facial expression.

The victory of the new style was not, however, immediate, and many painters went on working in the old manners. Carle van Loo (1705–65) continued to produce baroque mythologies – violently attacked by Diderot – till his death, and Jean-Honoré Fragonard (1732–1806), who survived the Revolution, evolved a new kind of rococo eroticism, which is saved from being banal by the brilliance of the handling and colour. Pierre-Paul Prud'hon (1758–1823), who lived also till after the Revolution, worked in a style which owed much to Correggio technically and had also some of his soft sensuality. Other painters, such as Nicolas Lavreince (1737–1807) and Louis-Léopold Boilly (1761–1845), specialized in small works of a mildly salacious character.

An even more radical change was taking place in the painting of domestic subjects, which was deeply affected by *sensibilité*, already popular in the novel and in the theatre. The great exponent of the new style was Jean-Baptiste Greuze (1725–1805), whose sentimental and moralizing scenes are the equivalent in painting of the *drames* of Diderot, the great supporter and exponent of his art. The paintings of Greuze fall into two main categories: the strictly moralizing paintings, such as the *Malédiction paternelle* or the *Mauvais fils puni* (Louvre), which roused Diderot to some of his most splendid pieces of imaginative criticism, and his portraits of girls, with doves, cats, or a *cruche cassée*, which appealed equally strongly to his sensibility and his sensuality. Greuze is indeed typical of the ambiguity of the epoch – manifested with equal clarity in the writings of Diderot – with its desire to reform, but also its determination to enjoy the pleasures of the senses.

The paintings of Greuze are the most complete expression of *sensibilité* in the visual arts, but other artists painted scenes of domestic life with a certain touch of sentimentality. One of these, Bernard Lépicié (1734–84), was a painter of considerable skill, with a delicate sense of colour, who would probably be better known if he had not been completely overshadowed by Jean-Baptiste Siméon Chardin (1699–1779). Chardin's genre scenes have a delicacy and a subtlety of observation unparalleled in the eighteenth century. He never points a moral,

nor are his paintings ever sensual. He is a pure observer, noting little scenes of domestic life with humour and detachment, fascinated – almost like Degas – with the poses of women scouring pans or working a churn, and amused by the naïve and sometimes prim actions of children. But above all he is supreme in the rendering of light falling on the surface of clothes in his figure subjects, or on fruit and pots in his still lifes. Unlike the Dutch masters of the seventeenth century, he is not interested in painting silks or fine china; his preference is for the rougher surfaces of wool or linen and for the coarse pottery of the kitchen; but from these he constructs compositions with a monumentality and a simplicity that can properly be called classical.

It is not surprising that a generation which admired Greuze and Chardin should have been interested in the paintings of the Le Nain brothers, but it is interesting to notice that of the two most important collections of their paintings one belonged to a member of a great noble family, the Duc de Choiseul, and the other to a rich bourgeois, Poullain. The same is true of Greuze and Chardin: their themes and even the sentiment which inspired them may have been bourgeois in origin, but their works appealed to aristocratic collectors as much as to their more recently enriched competitors.

Diderot was almost as much moved by the landscapes of Claude-Joseph Vernet (1714–89) as by the figure paintings of Greuze, and largely for the same reason. In the seventeenth century landscape had been the setting either for grand historical themes, as with Poussin, or for idyllic subjects, as with Claude. Vernet regarded nature as the reflection of the moods of man and of the drama of his existence. He was the first French painter to depict the horror of mountains, the violence of waterfalls, and the power of nature to dominate and destroy man. He had a predecessor in the Italian Salvator Rosa, but, whereas Rosa populates his landscapes with shepherds or bandits, almost without action, Vernet depicts actual human tragedy: the bridge carried away by the mountain stream and hurling the coach into the abyss, the ship wrecked near the shore, watched by the terror-stricken families of the crew. Sometimes his mood is calmer and in many of his coast-scenes he shows fishermen peacefully seated round a fire under the light of the moon – but always the human message dominates, and the message is that of Jean-Jacques Rousseau or Bernardin de Saint-Pierre.

Other types of landscape were, however, also painted. Hubert Robert (1733–1808) studied in Italy and came back with his

sketchbook filled with drawings of the ruins of Rome and the decaying villas of Frascati and Tivoli. These he used as a basis for compositions which are reflections on the passage of time and the decay which overcomes even the greatest civilizations. He extended this idea in one unexpected direction by painting a series of pictures showing the Louvre and other modern French buildings as they would look in a state of ruin, thus projecting nostalgic admiration for ruins into the future. In his themes Robert paid tribute to *sensibilité*, but his treatment of them was markedly classical, particularly in its restrained range of cool colours. Another exponent of this approach to colour in landscape was Louis-Gabriel Moreau, called Moreau le Vieux (1739-1805), whose views of French parks and châteaux develop the discoveries of Desportes and lead up, through his immediate successor, Pierre-Henri Valenciennes (1750-1819), to the landscapes of Corot and other painters of the early nineteenth century.

The architecture of this phase is magnificently represented by the work of Ange-Jacques Gabriel (1698-1782), who led a strong movement towards classicism based partly on a return to the style of François Mansart. His most important commission was the designing of the Place Louis XV, now the Place de la Concorde (1754). With its two magnificent palaces on the north side, it is one of the finest examples of large-scale layout in the whole eighteenth century and was even finer when it had the equestrian statue of the king in the middle and the moats round the central space hollowed out. The interiors of the two palaces, and also that of the École Militaire (planned 1751), show the change in decoration which accompanied the general move towards classicism. The curves of the rococo give way to straight lines, and details are freely borrowed from ancient models, but a strong element of the delicacy and refinement of the rococo phase lingers on, till it was finally banished by the severity of the Empire style. Gabriel's skill in planning and the delicacy of his decoration on an intimate scale are seen to perfection in the Opéra at Versailles (planned 1763) and at the Petit Trianon, begun in 1761 for Madame de Pompadour and later remodelled for Marie-Antoinette.

Jacques-Germain Soufflot (1713-80), a younger man than Gabriel, went still further towards classicism. Following the theories propounded by the Abbé Laugier, he banished the use of arches over columns and replaced them, in accordance with ancient practice, with a flat entablature. His most famous building, the church of Sainte-Geneviève, now the Panthéon (begun 1757), reflects the renewed feeling of classicism

in its huge free-standing portico, based on the Roman Pantheon, and in the severe lines of its dome.

In the two decades before the Revolution architecture went through a curious phase, which combined a stricter classicism in detail with a fantasy of invention which can only be called Romantic. The most interesting architect of this phase, Claude-Nicolas Ledoux (1736–1800), began work in the tradition of Gabriel, but in 1775 he was commissioned to design a complete new town at the salt-mines of Chaux, near Besançon. He designed it on a circular plan, with the administrative buildings at the centre and houses for the workers on radiating and concentric streets. The effect of the whole is very impressive, and the detail is lively, consisting of a mixture of ancient Roman motives, with elements taken from the architecture of Michelangelo. Ledoux was also responsible for designing the customs houses at the gates of Paris in the new Enceinte des Fermiers-Généraux, built between 1784 and 1789, of which three survive: the little Rotonde in the Parc Monceaux, the massive block at the Barrière d'Enfer, and the cylindrical building at the Porte de La Villette.

In his later years Ledoux found it difficult to obtain commissions, but he produced a series of projects which embodied his Rousseauist social ideas and his passion for pure geometrical forms, which sometimes led him to design buildings in the form of spheres. Not unnaturally these projects were never executed, but they are recorded in a series of engravings by the architect himself, published in 1806 with the characteristic title: *L'Architecture considérée sous le rapport de l'art, des mœurs et de la législation*. A similar mixture of grandiose ideas and classical detail is to be found in the designs of Ledoux's contemporary, L. E. Boullée (1728–99), of which very few were actually carried out.

By far the most important figure of the neoclassical phase in France is the painter Jacques-Louis David (1748–1825). David was trained in the mildly classical idiom of Vien, but the vital factor in his formation was his stay of eleven years in Rome, from 1774 to 1785. Here he came under the influence of the group which had been formed round Winckelmann and Anton Raphael Mengs, who had set up a quite new classical ideal, based on admiration not only for the heroic times of the Roman Republic, but also for ancient Greece. In 1784 David painted what was the first great manifesto of the new school, *Le Serment des Horaces* (Louvre). In this picture he returned to the ideals of Poussin, both in his choice of subject and in his style, which has the noble

severity of Poussin's works of the 1640s. The painting, which had an enormous success when it was shown in the artist's studio in Rome, was certainly intended to convey a lofty moral message, but it is doubtful if David really meant to give it the political implications which were read into it when it was shown on his return to Paris in 1785, where it was seen as a panegyric of patriotism and of a display of courage in the defence of a democratic state. During the Revolution David became in effect dictator in matters connected with the arts. He was responsible for organizing the *fêtes* given by the Republic, but he made his most significant contribution to the art of the Revolution by his painting of *La Mort de Marat* (Brussels). This is a picture of the most dramatic simplicity and a novelty in the history of painting in that it portrays a contemporary historical event in direct terms, without the use of allegory which was traditional in subjects of this kind. Formally it is moving by the bold simplicity of the design, divided into two almost equal parts by the edge of the bath, the upper half being largely a blank wall, and by the beauty of the cool colour and the nervous brushwork. At the fall of Robespierre David was arrested, but was soon released and retired to the country, where he painted two portraits of his hosts, Monsieur and Madame Sériziat (Louvre), which are among the most accomplished portraits of the period.

When Napoleon came to power, he appointed David as his official painter, and the artist executed many portraits of him as General, First Consul and Emperor. He was also commissioned to paint the great ceremonies of the Empire, of which the *Sacre de Napoléon I* (Louvre) is the most celebrated. It lacks the fervour of the *Marat*, but the artist has solved in a masterly way the problem of combining into a coherent design several hundred figures, most of which had to be accurate portraits. In 1815 David, being known to have voted for the death of Louis XVI, fled to Brussels, where he continued to paint portraits and occasionally mythological subjects.

The other painter officially employed to record the events of the Napoleonic period was Baron Gros (1771–1835). He learnt his style not like David from classical models but principally from the study of Rubens, and his paintings, of which the *Pestiférés de Jaffa* (Louvre) is perhaps the most successful, have something of the robust naturalism of this master. The neoclassical tendency was represented at this time by Pierre-Narcisse Guérin (1774–1833) and Anne-Louis Girodet-Trioson (1767–1824), whose *Atala* (Louvre; 1808) was one of the most famous paintings inspired by Chateaubriand's novel.

The first half of the nineteenth century is dominated in art as in literature by the struggle between neoclassicism and Romanticism, with the difference that, whereas in literature the weight of the Romantic attack left their opponents fairly well crushed, in painting the struggle was more equal, as the classical party had among them one great painter, Jean-Baptiste-Dominique Ingres (1780–1867), who, like his rival Eugène Delacroix (1798–1863), the leader of the Romantics, lived on till long after their quarrel had been forgotten in the new battle over realism.

Ingres did not become a pure classical artist all at once. He was a pupil of David and, when in his studio, belonged to the group who called themselves *les Primitifs* and advocated a return to a simpler form of art than the over-polished classicism of their day. In some of his early works Ingres drew on sources which are more akin to Romanticism than to classicism, notably in the painting of *Le Songe d'Ossian* (1813; Montauban) and, to a lesser degree, the *Paolo and Francesca*, based on Dante. Surprisingly enough some of his early nudes, such as the *Baigneuse de Valpinçon* (Louvre), shown in Paris in 1808, provoked attacks from traditional critics, because the nude was thought to be ugly, on the grounds that it did not conform to the standards established by the generation of Guérin and Girodet-Trioson, but soon Ingres 'purified' his style and established himself as the successor to David and the champion of the ideals of the ancients, Raphael and Poussin. Ingres's conception of female beauty was based not on fifth-century-B.C. Greek sculpture, which was still hardly known – the Elgin marbles had been brought to England in 1816 but were not available to French artists – but on late Hellenistic models, and his art lacks altogether the virile quality of David's classicism. He excels, however, in the pursuit of a harmonious contour, which is not only beautiful in itself, but which perfectly describes the volume which it encloses. His innumerable studies from the nude are evidence of the persistence with which he pursued this search. At first sight Ingres's drawings and paintings of the nude seem to be entirely naturalistic, but their appearance is in fact deceptive, and he often takes great liberties with human anatomy for expressive or formal reasons, as with the famous neck of Thetis in *Jupiter et Thétis* (1811).

Ingres was also a great portrait painter. During his early years in Rome he made portrait drawings of visitors and their families, which, in addition to being interesting social records, have a remarkable crispness of drawing, but he also painted some vigorous oil portraits

of members of the French Civil Service in Rome, of which the *Monsieur de Norvins* in the National Gallery is typical. Later he evolved a magnificent and luxurious type of female portrait, in which dress and setting are as important as the sitter. Portraits like the *Madame Moitessier* of 1856 (National Gallery) convey the opulence of Second Empire society to perfection. The magnificent portrait of the rich and influential journalist Louis-François Bertin, founder of the *Journal des Débats* (1832; Louvre), records with equal vividness the tougher aspect of the period in finance and politics.

The success of Ingres was predictable, because he had all the skills necessary to please the society for which he painted, but the career of Delacroix is more puzzling. The paintings which he submitted to the Salon in the 1820s aroused the most violent attacks in the press and among the public, but in spite of this they continued to be accepted, and the *Barque de Dante* was actually bought by the State. It was said at the time that this was due to the influence of Talleyrand, who was believed, probably with reason, to have been his father.

Delacroix bore the brunt of the fight to establish Romantic painting, but the first shots were fired by a slightly older artist, Théodore Géricault (1791–1824), who, if he had lived, would have been an artist of almost equal importance. He was trained in the studios of Carle Vernet and Guérin, but at the age of twenty-five he went to Rome, where he studied ancient art in the spirit of the neoclassical artists, but he was also inspired by the scenes that he saw in the city, particularly by the race of riderless horses which took place once a year down the Corso. Some of his paintings of this are designed like Greek bas-reliefs, but they have a fire very different from the rather feeble classicism of his French masters, and in others he paints the whole setting of the scene with a naturalism unusual at that date. When he returned to France in 1818, he continued to paint horses, which were one of the great passions of his life, but in a different context. His subjects were taken from the Napoleonic Wars, but he chose to paint individual anonymous soldiers rather than the victories of generals, as in his *Cuirassier blessé* (Louvre; 1814), which has an energy and an individualism that are close to Romanticism. His greatest work, the *Radeau de la Méduse* (Louvre; 1819), was painted in a consciously political spirit, the subject being a naval disaster of which the Liberals had made a stick to beat the Government. It is a magnificent work of mixed characteristics: its composition is *mouvementé* and baroque, owing much to Rubens; its gruesome detail is naturalistic, but in its treatment of the

nude there are still strong traces of Géricault's study of ancient sculpture.

In 1820 Géricault brought the *Méduse* to be exhibited in London, and on this occasion he was struck by the naturalism and free handling of English painting, particularly in the work of the animal painters, including Ward and the young Landseer. On his return to Paris he produced a few lithographs which show these influences, and it is likely that, if he had not died in 1824 as the result of an accident while out riding, he would have developed in the direction later taken by Courbet. A similar tendency, though combined with a Romantic interest in the abnormal, is to be seen in a series of studies of various types of insanity which he made with the help of a well-known alienist.

The death of Géricault left Delacroix as the leader of the Romantic school. During the 1820s he asserted his personality through a number of paintings shown in the Salon. In 1822 the *Barque de Dante* (Louvre) shocked the critics and the public by the grimness of its subject and the freedom of its handling, based on a study of Rubens, which was thought to be due to mere lack of finish. In 1824 the *Massacre de Scio* (Louvre) caused an even greater sensation, partly for the same reasons, and partly because of the freshness of colouring which Delacroix introduced at the last moment as the result of seeing Constable's *Haywain* in Paris earlier in the same year. In 1827 his *Sardanapale* (Louvre), one of his most accomplished paintings, was also thought to be unnecessarily brutal, though its technical skill could not be ignored.

The literary sources on which Delacroix drew are significant. First Dante in the *Barque*, then Byron in *Sardanapale*, and Shakespeare in a number of small paintings and lithographs. In 1825 he paid a visit to London and was deeply impressed by the rich colouring and impasto of Lawrence's portraits, and also by the genre painting of Wilkie, in which he admired the power of observation and the liveliness of touch. He was also a regular visitor to the theatre, where he saw both Kemble and Kean in Shakespeare, greatly preferring the nervous and lively acting of the latter to the declamation of the former.

In 1832 he went to Morocco, where he was impressed by the dignity of the Arabs, whom he regarded as the Romans of the nineteenth century, and where he was stimulated by the strong light and the intense colours which it gave by reflection to objects in shadow. The exploration of colour was in fact Delacroix's great contribution to French painting. He learnt much from Rubens and Constable, but the richness of his harmonies is all his own. In his last years, particularly in the

frescoes of the Chapelle des Anges in Saint-Sulpice (1853–61), he goes even further and in his use of little touches of pure brilliant colours comes near to the bolder experiments of the impressionists.

The interest in painting everyday scenes, which is implicit in some of Géricault's last works, was the foundation of the realism which was to be the most important movement of the mid-nineteenth century. In the work of Honoré Daumier (1810–79) it took a special form owing to his preoccupation with politics, in which he was a strong supporter of the Left throughout his career. He earned his living mainly by doing caricatures for Le Charivari and other opposition papers. In the early stages these consisted of direct attacks on Louis-Philippe and his Ministers, but, when this proved too dangerous, he turned to satire on the middle classes. At the time of the Commune he once again became quite explicit in his support of left-wing views. He is now principally remembered for his social satires, which present a vivid picture of the smugness of middle-class life, but in his relatively rare paintings he is more positive, and those which represent workers at their occupations, painted with sympathy but without sentimentality, are perhaps his most imaginative creations.

Landscape painting also moved towards a more naturalistic approach in the early nineteenth century. The first to break with a neoclassical type of landscape based on the study of Poussin and represented by Bertin (1755–1842) and Michallon (1796–1822) was Georges Michel (1763–1843), who turned for inspiration to the art of Rembrandt and the scenery that he saw in the suburbs of Paris, particularly in the then deserted hill of Montmartre with its windmills; but the main change was effected by the Barbizon School, called after the village on the edge of the Forest of Fontainebleau where it was established. Its original members were Théodore Rousseau (1812–67), Charles-François Daubigny (1817–78), Constant Troyon (1810–65) and Narcisse-Virgile Diaz (1808–76), but both Camille Corot (1796–1875) and Jean-François Millet (1814–75) were attached to it for a time. Their main principle was the direct study of nature, though in practice they saw it through the eyes of seventeenth-century Dutch painters, such as Hobbema or Jacob Ruisdael, and English artists of the previous generation, above all Constable, whom they took as models instead of the classical landscape painters, Claude and Poussin, admired by the previous generation. They continued to paint their finished pictures in the studio, but they made drawings and small oil-sketches in front of the actual scene they were to paint.

Corot spent many years in Italy, where he painted small landscapes of extraordinary calm and luminosity directly inspired by the Roman Campagna. Later he made a great success with his silvery landscapes, composed of frail wispy trees and peopled by shepherds or nymphs, but he continued to paint more spontaneous canvases, both of landscape and of figures, to the end of his career. Millet also differed from his companions in that he painted not only landscapes but compositions with peasant scenes, of which the most famous are the *Angelus* and *Les Glaneuses* (Louvre). Diaz came near to the Barbizon painters in his landscapes, but he was more at home in the painting of romantic, pastoral or mythological scenes in rich colours and thick impasto, a technique derived from the study of Venetian painting and of Watteau. Adolphe Monticelli (1824–86) scored a more popular success by painting *fêtes champêtres* in a similar but even more succulent technique.

Realism and Impressionism

The most explicit and vocal champion of realism was Gustave Courbet (1819–77). He was something of a megalomaniac, and in his early self-portraits he painted himself as a Romantic bohemian hero. Soon, however, he was caught up by the socialist movement and became a friend of Proudhon, whose theories he purported to embody in his painting. His enormous *Enterrement à Ornans* caused a scandal at the Salon of 1850, and at the International Exhibition of 1855 his works, which included the *Atelier du Peintre* (Louvre), were so badly hung that Courbet removed them and exhibited them in a room specially hired for the purpose, thus inaugurating the 'one-man show'.

Whether or not the *Enterrement* fulfils the programme set out by Proudhon in his pamphlet *Du Principe de l'art et de sa destination sociale*, it is undoubtedly a revolutionary work. The mere fact of painting an ordinary funeral on the scale usually reserved for history was a break with a well-established tradition, but the artist sinned further in neglecting all the classical rules of composition in favour of a long drawn-out procession which straggles across the composition, and in painting the figures with no attempt at embellishment and in a rough and vigorous technique. In some of his later paintings, such as *Les Casseurs de pierres* (1853; Dresden), Courbet continued to treat subjects with obvious social implications, but the works that were to influence his successors were his landscapes and his still lifes. Here his heavy greens and earth colours, applied in broad strokes, often with the

palette-knife, gave his paintings a boldness of structure lacking in the productions of the Barbizon School. A more romantic spirit appears in his sea-scapes, particularly in the several versions which he painted of *La Vague*, in which he conveys the power of the ocean with a quite novel intensity.

Édouard Manet (1832–83) was mainly influenced in his early work by his study of Velasquez and other Spanish painters of the seventeenth century, whose works he knew in French private collections even before his brief visit to Spain. In this vein he painted a number of picturesque figures in subdued tones of greys and browns, with a subtle observation of tonal values, but in the early 1860s he struck out on a new line, which caused an even greater storm than the more deliberately revolutionary paintings of Courbet – much to Manet's distress, because he was at heart a conservative and would have enjoyed popular success. His paintings were rejected at the Salon of 1863, but some were shown in the famous Salon des Refusés in the same year. The *Déjeuner sur l'herbe* (1863; Louvre) and *Olympia* (1865; Louvre) shocked the public by their subjects, the first because it showed a naked woman seated with clothed men – although it was pointed out that Giorgione had done the same in his much admired *Concert champêtre* – the latter because it depicted a little French tart and not a Venus, and because the black cat and the black servant were thought to have sinister erotic implications. However, the technique was thought to be equally outrageous, because Manet had broken with the tradition of sombre colour rising from a dark background and had painted in flat areas of bright colours on white ground, a formula which he derived partly from the study of Japanese prints, which were beginning to be known in Paris. In the 1870s Manet, who was a friend of the impressionists, was influenced by their discoveries in the painting of light, and his last works, particularly the *Bar aux Folies-Bergère* (Courtauld Institute Galleries, London), combine his love of flat areas of colour, particularly black, with a dazzling treatment of the effect of light on glasses, bottles and flowers.

The impressionist group was formed in the early 1870s and held its first exhibition in 1874. The founders were Claude Monet (1840–1926) and Auguste Renoir (1841–1919), who were later joined by Camille Pissarro (1830–1903). Round them were grouped certain painters of less originality, such as Alfred Sisley (1839–99), who remained constant to the principles of impressionism all their lives; others, like Paul Cézanne (1839–1906), who were influenced by their principles

for a time but moved on to different ideals at a later date; yet others, like Edgar Degas (1834–1917), who sympathized with the aims of the group but stood slightly apart.

In the first half of the sixties Monet was painting in a manner principally influenced by Manet, with broad areas of strong colours, but by about 1867 he became insistent on the principle that open-air scenes, whether pure landscape or figure groups, must be painted on the spot and not in the studio. In 1869 he was joined by Renoir and Pissarro, and all three painted a series of views at a point on the Seine called La Grenouillère, in which they attempted to capture the fleeting effects of light on trees and water. In the early seventies they carried the idea further, using purer colours and developing the discovery, hinted at by Delacroix and Manet, but only fully worked out by Monet and his friends, that shadows on an object are not merely darker than the part in light, but actually different in colour. Monet insisted that the landscape painter must not only record a particular view, but record it at a particular moment of the day and in particular light, and in the 1880s he painted two great series of canvases to establish his point, one of haystacks and one of the façade of Rouen Cathedral (several versions in the Louvre). In these paintings he allows the light almost to dissolve the solid forms on which it falls. In his later years he concentrated on painting the water-lily pond in his garden at Giverny and, in two magnificent series of decorative canvases of this (Louvre), carried the dissolution of solid forms so far that they have been claimed – probably without justification – as one of the sources of abstract art.

Pissarro continued for many years to work in the idiom of impressionism, but he was always more interested than Monet in figure painting, and his greater concern for social problems – he was by conviction an anarchist – often led him to choose peasant subjects for his compositions. In the 1890s he was attracted for a few years by the ideas of neo-impressionism and modified his technique accordingly.

Degas started as a classical painter, influenced by Ingres and the study of Raphael, but in the 1870s he became interested in seizing the quickly changing poses of horses and dancers in movement. In thus concentrating on a single instant his method presents an analogy with the impressionist's treatment of light, but he never turned, like them, to the painting of landscape. He also differed from the pure impressionist in having a keen interest in the problems of space-construction. In his later years, as his eyesight began to fail, he changed his technique and

his subjects. He found he could control the pure colours of pastel better than the more subtle tones attainable in oils, and he chose subjects which did not involve the observation of rapid movement. In this phase he made principally studies of women washing or drying after a bath. His superb draughtsmanship enabled him to give monumental grandeur to a series of poses in themselves clumsy and even ugly. He also made brilliant wax statuettes of dancers and horses which, after his death, were cast in bronze.

The appearance of impressionism confirmed the breach which had been growing between fashionable art and 'advanced' art, or, as we should say, between lowbrow and highbrow art. The Salon fostered various brands of fashionable art, of which the portraiture of Léon Bonnat (1833–1922), the sensuality of Adolphe Bouguereau (1825–1905) and the minute craftsmanship of Ernest Meissonnier (1815–91) were the most popular. On the other hand the division between the two factions was never complete. Bonnat was a close friend of Degas; Fantin-Latour (1836–1904), who enjoyed great popular success with his flower paintings, painted a composition entitled *Hommage à Delacroix*, in which he included portraits of Manet and Baudelaire; the models that Cézanne studied most carefully were the great Venetians of the sixteenth century, who would also have been acclaimed in the Beaux-Arts; and most of the impressionists went on trying to get their paintings accepted by the Salon jury, even though they disapproved of most of the work exhibited there.

In sculpture the opposition was even less sharp. Jules Dalou (1838–1902), who started as a fashionable sculptor, held strong left-wing views in politics, and during his exile in England after the Commune evolved a very serious kind of naturalism; Antoine-Louis Barye (1796–1875), who enjoyed international success, learnt much from Géricault and Delacroix in the depiction of animals; and Auguste Rodin (1840–1917), by far the greatest sculptor of the period, was technically much influenced by Jean-Baptiste Carpeaux (1827–75), although he applied the virtuosity of the latter to much grander and more monumental works. His rough treatment of the surface of the clay in which he modelled his figures produced an effect of varied light and shade which has some analogy with the methods of the impressionist painters.

The most important innovations in nineteenth-century French architecture took place in town-planning and in the development of new materials for building. The new layout of Paris was begun by

Napoleon I, who was responsible for the western part of the Rue de Rivoli (by Charles Percier (1764–1838) and Pierre-François Fontaine (1762–1858); begun in 1802), the Arc de Triomphe de l'Étoile (mainly Chalgrin (1739–1811); begun 1806), and the Madeleine (Pierre Vignon (1762–1828); begun 1808), but the great transformation of Paris was carried out under the Second Empire by Baron Haussmann, Prefect of the Seine, who replanned the Cité and laid out boulevards linking the new stations (Gare de l'Est and Gare du Nord) and the Opéra with the centre of Paris. At the same time the Rue de Rivoli was completed and the Louvre extended along it to link up with the Tuileries, on the designs of Louis Visconti (1791–1853) and Hector Lefuel (1810–80). The Opéra, designed by Charles Garnier (1825–98), and decorated on the outside with Carpeaux's famous group, *La danse*, was the most spectacular symbol of Second Empire luxury.

Meanwhile architecture of a different kind was being evolved, based on the use of iron for the structure of buildings. The first mature example of the new technique was the Bibliothèque Sainte-Geneviève, built in 1843–50 by Henri Labrouste (1801–75), who later built the reading room of the Bibliothèque Nationale, but it was soon adopted by ecclesiastical architects, as in Saint-Augustin (1860–1) by Louis-Auguste Boileau (1812–96). The International Exhibition of 1889 provided the opportunity for the two greatest manifestations of the new technique in the Hall des Machines, built by Ferdinand Dutert (1845–1906) and Henri Contamine (1810–97), which had a span of 385 feet, and the Eiffel Tower, a thousand feet high, constructed by Gustave Eiffel (1832–1923). In the last decade of the century reinforced concrete was introduced by Anatole de Baudot (1834–1915) in Saint-Jean-de-Montmartre (1894–9). In the structure of this church Baudot followed the lines of Gothic vaulting, but the new material was used in a manner more in accordance with its real nature by Auguste Perret (1874–1954) in his block of flats at 25 bis Rue Franklin (1902–3). At the turn of the century the use of iron was adapted to the art-nouveau style, which scored a great success in the decorative arts as well as in architecture. Of the most famous monuments in this manner, the Métro stations designed by Hector Guimard (1867–1942) in 1900, very few now remain.

The Gothic Revival, which was essentially a northern movement, produced relatively little effect in France, though Sainte-Clotilde (1846–57) by Franz Christian Gau (1790–1853) and Théodore Ballu (1817–74) is a prominent example of the style, the virtues of which

were enthusiastically expounded by Viollet-le-Duc (1814–79) in his theoretical writings, which also contain many ideas foreshadowing modern functionalism. His bad reputation for over-restoring medieval churches and châteaux has been exaggerated, and in fact he did much to save buildings which would otherwise have perished.

The Late Nineteenth Century

The impressionist painters continued to work till the early years of the twentieth century, but after 1876 they ceased to exhibit as a group and their position in the vanguard of the advanced school was taken in the 1880s by other artists, who had learnt much from them but later modified or even rejected their principles. These artists are loosely described as the post-impressionists, but they never formed a coherent group and indeed were far from unanimous in their admiration for each other's work.

Cézanne, after an early Romantic phase, when he applied the dark colouring of early Manet and the heavy brushwork of Courbet to erotic themes, worked very closely with Pissarro for several years in the early 1870s and absorbed the new impressionist technique, but in the eighties he settled down in Aix-en-Provence and devoted himself to an unremitting study of the effect of light on his native landscape and of the interaction of colours and shapes in still lifes carefully disposed in his studio. These subjects he studied with a fixed intensity which often revealed relationships which the more rapid observation of the impressionists had overlooked. His observation showed not only that colours juxtaposed affect each other, but that forms can behave in the same manner, and this discovery led him to a series of subtle adjustments of contours which have often been put down to systematic distortion. In fact continuous refinement of his forms caused his compositions – when they were fully *poussées*, as he would have said – to have a meticulous organization in space and on the surface undreamt of by the impressionists and rare in the work of any artist. In his last years his palette became richer and the breaking-up of forms more pronounced; but in his landscapes, still lifes and portraits he never departed from his strict observation of nature. In his *Baigneuses* the case was different, as he was unable to bring himself to paint from the naked model, and there is about them an arbitrariness lacking in his other works. The fact that he painted in seclusion at Aix had the result that his work was little known in Paris, and it was not till the great

retrospective exhibition in 1904 that the younger generation came to appreciate his achievement.

Early in the 1880s Renoir was affected by the dissatisfaction with impressionism felt by many of his friends, and the sight of the great masterpieces of Renaissance painting on a visit to Italy in 1881–2 made him feel that he must submit himself to a more severe discipline, particularly in drawing. The result was a series of cold figure paintings, in which he almost seems to be emulating Ingres, but he emerged from this 'reformation' with a new method of painting the nude in a series of grand and simplified masses and in a rich colouring which gradually changed from an almost impressionist palette to much hotter tones in his very last works, such as the big *Baigneuses* in the Louvre.

Though Vincent van Gogh (1853–90) was born and bred in Holland, his most important works were painted in France and he cannot be left out of any history of French painting. As a young man his aim was to enter the Church, but in this he failed, and after a short period working among the miners of Le Borinage in Belgium he decided to devote his whole energies to painting. The sight of impressionist and neo-impressionist paintings in Paris, where he spent about a year in 1886–7, caused him to abandon the sombre style which he had learnt from Dutch painters like Josef Israels and to adopt a brilliant palette, composed solely of pure colours. This tendency was confirmed by his admiration for the rather crude Japanese prints which were beginning to be known in Paris. In the spring of 1888 he moved to Arles, attracted by the sun and the cheapness of living. Soon afterwards he was joined by Gauguin, whom he attempted to kill in an attack of madness. In spite of recurring crises he continued to paint, first in a lunatic asylum at Saint-Rémy, and later under the care of Dr Gachet at Auvers, near Pontoise. He used the brilliant palette which he had learnt in Paris for purposes quite foreign to the inventors of the technique. For him colours had a meaning of their own, and he used them to express his feelings about people or places, irrespective of whether they conformed to nature. These colours were applied in vigorous brush-strokes, in the form of commas or S-shapes, which make the surface of his canvases vibrate, and the result is a kind of painting which conveys the fervour of his emotions about people, trees or flowers. The works painted in Arles are permeated with the brilliant sun of Provence, but in those executed at Saint-Rémy his palette becomes cooler. While he was confined there he had difficulty in getting models, and he often copied engravings after Rembrandt or Gustave Doré, translating them wholly

into his own language. In the last few months of his life, spent at
Auvers, his handling became almost frantic and his colours wild and
dramatic, but there was no sign whatsoever that his talent was ex-
hausted, and these paintings are among the most moving works that
he ever produced. On 29 July 1890, in a fit of despair, he shot himself.

Like Van Gogh, Gauguin (1848–1903) came to painting late, though
from a different background. Till the age of thirty-five he worked as
a stockbroker, but then, having come into contact with impressionism,
he threw up his career and abandoned his family in order to devote
himself to art. He soon found the impressionist doctrine unsatisfying
and developed ideas on the symbolical value of colours which were
allied to those of Van Gogh. His method of painting, however, was
quite different and, instead of torturing the canvas with nervous
touches of colour, he laid it on in large almost unbroken areas, arguing
that 'if you want to paint green, a metre of green is greener than a
centimetre'. He left Paris for Brittany, where he found it cheaper to
live, and at Pont-Aven founded with Émile Bernard (1868–1941) a
colony of artists who espoused his ideas, of which the most important
was that a painting was essentially a flat surface decorated with areas
of colour which must possess their own decorative coherence, irrespec-
tive of their relation to the natural objects depicted. In 1891 Gauguin
went to live in Tahiti, partly for reasons of economy, and partly
because he was attracted to the simple life of the natives and the
exotic beauty of the island, which in fact supplied the ideal subject-
matter for his rich, decorative compositions. Many of these were
based on the beliefs of the natives, which Gauguin found more con-
genial than the conventional religion and over-intellectualized philo-
sophy which he had left behind in Europe. In 1901, having quarrelled
with the French administration over his attempts to stand up for the
rights of the natives, he moved to the Marquesas islands, where he
died in extreme misery two years later.

The painters just mentioned all worked according to a series of
personal ideas – Cézanne talked of his *petite sensation*, Renoir believed
in the sensuousness of painting, Van Gogh and Gauguin in the value
of colour – but they all worked essentially from instinct and none of
them consciously evolved an aesthetic doctrine. This was left for
Georges Seurat (1859–91), the inventor of neo-impressionism or
pointillisme. Seurat's starting-point was the impressionist use of strong
pure colours and their discovery of coloured shadows, but, whereas
they applied their ideas empirically, Seurat, under the influence of new

discoveries in optics, particularly those of Chevreul and Clark-Maxwell as popularized by Charles Blanc, worked out an almost scientific approach towards colour. He believed that in any group of objects on which light falls there are three kinds of colour: the local colour, or colour which the object would have under white light; the colour which it receives from the source of light (e.g. yellow, if the source is sunlight); and a third colour due to the fact that one colour juxtaposed to another induces its complementary in it (e.g. yellow induces purple, green red). Seurat applied the three kinds of colour separately in minute dots, so that the fusion takes place optically, on the retina and not on the canvas. In addition Seurat evolved theories about the emotional effect of lines in composition – those rising from a base line conveying joy, those sinking sorrow, and so on – and was deeply interested in the application of certain mathematical proportions, particularly the Golden Section. He did not come to these theories immediately, and in some of his earlier works, like *Une Baignade* (1884; Tate Gallery), although the proportions are carefully calculated, the *pointillisme* is perceptible only in certain areas which the artist retouched later. The method was fully developed in the *Grande Jatte* (1886; Chicago) and the *Poseuses* (1888; Barnes Foundation, Merion, Pa.), and in the *Poudreuse* (1889–90; Courtauld Institute Galleries, London). The result is a kind of painting which at times seems cold but which is infinitely satisfying in the perfection of its harmony and in the monumentality of its forms. Seurat has been compared with Piero della Francesca, and the comparison is neither silly nor accidental, because Seurat knew and studied copies after Piero in the École des Beaux-Arts. In his last works, *Le Chahut* (1889–90; Otterlo, Holland) and *Le Cirque* (1890–1; unfinished, Louvre), he seems to be breaking away from the rigid rectangular compositions of his earlier paintings and to be introducing new curved forms, partly influenced by art-nouveau.

By the first years of the nineties the impulse of impressionism was spent; Van Gogh and Seurat were dead, Cézanne and Gauguin were in hiding, and Renoir could never have become a *chef d'école*. It is not surprising, therefore, that the lead passed to others, or rather it would be truer to say that there was no leader, but several individual artists or groups whose ideas and methods had little in common.

Of the individual artists the most remarkable was Henri de Toulouse-Lautrec (1864–1901). Lautrec lived in and painted exactly the oversophisticated world that Gauguin had gone to Tahiti to escape, and he produced the most vivid and yet the most detached commentary on

bohemian life in Montmartre in the nineties. Deformed as the result of a riding accident, he was unable to fulfil the ambitions of his aristocratic parents, with which in any case he did not sympathize, and he spent most of his short life among the music-halls and brothels of Paris, which provided the subjects for almost all his paintings, drawings and lithographs. His brilliant draughtsmanship was partly learnt from the study of Degas – modified by the curves of art-nouveau – but his approach was entirely different. Degas was interested in a detached way in the curious movements of human beings engaged in their everyday occupations. Lautrec was fascinated by the human implications of what he saw and was intent on recording his reactions. These varied according to the type of subject that he treated. He was savage to the rich clients of the Moulin Rouge, appreciative, perhaps with a touch of irony, of the talents of a Jane Avril or an Yvette Guilbert, and moving when he depicted the boredom and squalor of the life led by the prostitutes in the *maisons-closes*. In his desire to treat in paintings human types and human problems – albeit of a rather specialized type – he stands apart from his contemporaries, the post-impressionists, and is nearer in spirit to the great social satirists, Goya and Daumier.

Another painter active in the nineties who does not fit into any category is Henri Rousseau (1844–1910), generally known as Le Douanier Rousseau. Till he was forty he was an employee in one of the customs offices at the fortifications of Paris (a painting of the *Octroi* is in the Courtauld Institute Galleries, London), and painting was for him only a hobby, but on his retirement in 1885 it became his main occupation. His work was 'discovered' by Signac and Gauguin and later appreciated by Picasso and Apollinaire for the spontaneity and freshness of the artist's vision. Rousseau's paintings are, however, far from being naïve. They are the result of very careful thought and are based on a long study of the Old Masters in the Louvre. Admiration for Rousseau started a fashion for 'primitive' painting, but unfortunately none of the artists who claimed to belong to this category had anything of the true imaginative power which saves Le Douanier's work from being trivial.

The most prominent group in French art of the nineties was that of the symbolists, but they were far from being united in their views. Some drew their ideas from Gauguin's conception of colour, and others, like Gustave Moreau (1826–98) and Puvis de Chavannes (1824–98), were inspired by religious and mythological themes, but they treated

them in wholly different manners, Moreau in rich jewel-like colours, Puvis in a decorative style derived from the study of Renaissance frescoes. The most imaginative of them, Odilon Redon (1840–1916), built up his compositions round more allusive and more poetical ideas, often taken from Poe or from ancient legend or mythology. What they had in common was a belief that a painting was above all an object which must be beautiful in itself, in its colour, and in its craftsmanship, and that these elements serve to convey a spiritual beauty beyond that of the material world. As Aurier wrote, their art was to be 'ideal, symbolical, synthetic, subjective and decorative'. Eugène Carrière (1849–1906) was a friend of the symbolists and shared their view of painting as a spiritual art, but his themes were simple domestic subjects, often taken from his own family life, painted in very subdued tones, almost in monochrome, and in a soft technique without sharp outlines.

In some ways Carrière forms a link with the second group in the nineties, the Nabis, who belonged to a younger generation. Their name was taken from the Hebrew word for prophet, and in their earlier stage they shared many of the beliefs of the symbolists and of Gauguin, to which they were introduced by Paul Sérusier (1863–1927). Maurice Denis (1870–1943) applied the theory primarily to religious art and learnt much from early Italian painting; Ker Xavier Roussel (1867–1944) was inspired by classical mythology, but the two most significant members of the group, Pierre Bonnard (1867–1947) and Edouard Vuillard (1868–1940), soon abandoned the literary associations of this early phase and developed a style, sometimes called intimist, which they used for small paintings of domestic scenes. They retained the symbolist idea that a picture must be a painted area attractive to the eye and coherent in itself by eliminating all effect of depth and treating the canvas almost as if it were a tapestry or an embroidery. In many of their works of the nineties they embody the sinuous curves of art-nouveau as the basis of their surface patterns. In their early works both artists used a restricted palette of subdued and delicate tones; Vuillard continued to work in this vein, but Bonnard, in his later work, employed a palette of warm, glowing tones, dominated by reds, oranges and luminous purples. Though limited in their range compared with many twentieth-century artists, they were gifted with a high degree of sensibility. Maurice Utrillo (1883–1955) was never a member of the Nabi group, but his early views of Paris streets are in a palette closely allied to theirs and have a somewhat similar intimacy.

In sculpture the transition to the twentieth century is marked by the career of Aristide Maillol (1861–1944). He began as a tapestry designer under the influence of Gauguin and was for a time in touch with the Nabis, but in about 1900 he turned to sculpture, in which he evolved a formula for carving monumental figures of women in a style which owed something to Rodin, but much more to the study of Greek sculpture.

The Twentieth Century

The years between 1900 and the outbreak of the First World War were among the most eventful in the history of French art. They witnessed the establishment of *fauvisme* and the revolution brought about by the invention of cubism.

Fauvisme, of which the leading exponent was Henri Matisse (1869–1954), became a coherent school about 1904–5 and made its début at the Salon d'Automne of 1905. In certain respects the ideas of the *fauves* were based on immediately preceding doctrines. They accepted the importance of colour, they believed that a painting must be a coherent two-dimensional object, and they rejected classical canons of draughtsmanship. But they went much further than their predecessors: their colours were not merely pure, they were savage; they eliminated traditional perspective altogether, and they allowed themselves a quite new freedom in the distortion of the human figure for expressive or decorative purposes. Above all they entirely rejected the literary elements in painting, which had been vital to the symbolists and implicit in the art of Van Gogh and Gauguin. For them a painting was simply a painting; content was of quite secondary importance, and its relation to nature almost fortuitous. In fact the *fauves* applied in practice, and ruthlessly, what their predecessors had proclaimed in theory but had only carried out timidly. The result was a movement of quite extraordinary vitality which absorbed almost all the younger talent of the day. Matisse set the pace and created the first masterpieces in the new style: *Luxe, calme et volupté* (1904–5), which is still *pointilliste* in technique, *Bonheur de vivre* (1905–6; Barnes Foundation, Merion, Pa.), in which the flattening of forms and abolition of perspective are worked into an almost art-nouveau arabesque, and the two versions of *Le Luxe* (1907–8; Musée d'Art Moderne and Copenhagen) much grander in scale and more daring in their distortions. But other artists were infected by the enthusiasm of the moment and produced their own

variations of the manner. Albert Marquet (1875–1947) worked in a style very close to Matisse, but Georges Braque (1882–1963), André Derain (1880–1954) and Maurice de Vlaminck (1876–1958) painted landscapes in simplified forms combined with fiery colours, and even painters of altogether minor talent, such as Kees van Dongen (1877–1968), Raoul Dufy (1877–1953), Henri Manguin (1874–1943) and Othon Friesz (1874–1949), applied the new methods with seriousness and individuality.

One painter of great power, Georges Rouault (1871–1958), was associated with the *fauve* group, although his style was fundamentally different from theirs. He was a devout Catholic and a pupil of Gustave Moreau. In his earliest works he imitated the style of his master, but by about 1905 he moved to a quite different conception of art. Obsessed by the evil and hyprocrisy of conventional society, he showed up its weaknesses in a series of savagely painted pictures of smug bourgeois couples, judges and prostitutes, executed with the comminatory vehemence of an Old Testament prophet.

Amadeo Modigliani (1884–1920), an Italian who early settled in Paris, belonged to no group, but his flat, linear paintings of elongated figures and his rich, warm colouring embody some of the principles of the *fauves*, and he shared with them an interest in African art, on which many of his faces are modelled. His work has, however, a certain monotony which indicates a lack of invention.

Of the various artists just named most never went on from *fauvisme* to break new ground. Some, like Van Dongen and Dufy, became purely frivolous, while Derain, Vlaminck and Othon Friesz sank into academic repetition. In the years just before the First World War Matisse went on to a splendid phase, in which the violence of early *fauvisme* was tempered by a certain intellectual control, which led him to produce some of the richest and most beautifully organized compositions in early twentieth-century art. After the end of the war, he went through an almost rococo phase with his lightweight paintings of interiors at Nice, but in the mid-thirties he recovered much of his early vitality, and the *papiers découpés* of his last years are thought by many to be among his finest works.

Braque alone went on to a completely new phase and collaborated with Picasso in the creation of cubism. Pablo Picasso (b. 1881) had already shown his astonishing talent and versatility in the paintings of the Blue and Pink periods, of which the former have some affinity with symbolism in their melancholy atmosphere, and the latter some

relation to *fauvisme* in their flat, decorative quality; but he had been working in some isolation and in styles more conventional than *fauvisme*. In the famous *Demoiselles d'Avignon* (1906–7; Museum of Modern Art, New York), however, he broke through conventions which even the *fauves* had respected and at once took the position of leader among a slightly stunned group of colleagues. The *Demoiselles* was begun in a relatively conventional manner with a number of sketches in which the artist gradually refined the composition, but when the painting was half finished Picasso suddenly introduced completely new elements. He redrew one of the figures, so that the body and legs are seen from the back but the head is turned round so as to be seen almost full-face, thus breaking with the age-old convention of the single viewpoint. Secondly, he repainted several of the heads in a completely new idiom, based on the study of African masks, which Picasso and his friends had recently 'discovered'. The interest in African sculpture was in part due to a reaction against the over-sophistication of contemporary European culture, similar to that which drove Gauguin to Tahiti, but on Picasso it had a further effect because he was impressed by the manner in which Negro artists simplified the shapes of their images, reducing them to almost geometrical forms. It was this aspect of Negro sculpture rather than its savage or magical qualities which contributed to the development of cubism. It was about this time that Picasso and Braque began to work very closely together, each making his contribution to the new style. Through Braque Picasso came to study the late work of Cézanne, the lessons of which he applied in a series of landscapes painted in the summer of 1909 at Horta de Ebro. In these he made two further innovations: the abandoning of a single source of illumination, so that light and shade are applied in an arbitrary manner for purely formal reasons, and the rejection of central perspective, which in a sense was implied in the rejection of a single viewpoint introduced in the *Demoiselles d'Avignon*. In the following years, 1909–10, Picasso and Braque went further and further in the application of these principles, so that the forms of nature almost disappear as they are analysed into small facets seen from different angles and in different perspectives. Eventually these facets are extended, so that they almost take on a life of their own, and the same method of analysis is applied to the background, so that figure or still life merges with it into a single complex bas-relief, painted in a very restrained palette of grey-browns and greens. Then, in 1911, just as Braque and Picasso seemed on the point of breaking off all contact with the visible world, they began to

re-establish it by the introduction of details painted in an almost *trompe l'œil* style, of words from newspaper headings or popular songs, and finally of actual objects such as matchboxes and cigarette packets. These *collages* introduced the phase of cubism called synthetic, as opposed to the earlier analytical type.

Cubism was essentially the invention of Picasso and Braque, but other artists of great talent joined the group and made their own contribution. Some, like Albert Gleizes (1881–1953) and Jean Metzinger (1883–1956), were more distinguished as theorists than as creative artists, but their writings are of interest since they are the earliest expositions of cubist doctrine, apart from Apollinaire's articles brought together under the title *Les Peintres cubistes*. The most original painters were the Spaniard Juan Gris (1887–1927), whose approach to art had something of the intellectualism of Seurat but whose best paintings have also great delicacy, and Fernand Léger (1881–1955), a more robust artist, whose cubist paintings are stronger in colour and contain more direct allusions to nature than the works of Picasso and Braque.

Although cubism was essentially concerned with painting, Picasso and Braque also made 'constructions' in order to try out some of their formal experiments which involved three-dimensional effects. Hardly any of these constructions have survived, owing to the fact that they were made in perishable materials, such as cardboard and paper, but a few artists, of whom Jacques Lipschitz (b. 1891) was the most interesting, produced cubist sculpture in more permanent materials.

Cubism was the dominant school in Paris in the years before the First World War, but there were other groups influenced by their ideas though working towards different ends. One of these, called the Orphists, and led by Robert Delaunay (1885–1941), wanted to escape from the extreme intellectualism of cubism and to introduce light and colour. In Delaunay's early paintings the forms of nature are dissolved by light, not into the vague forms of impressionism but into facets like those of cubist painting, though less rigorously patterned. Later he went further and painted abstract compositions based on rectangles or circles of pure colour, transfixed by rays of light. The Orphists formed the nucleus of a group called *La Section d'Or*, which in 1911–12 attracted most of those artists who were on the fringe of cubism, including Léger and Gris, and others of great talent who had not committed themselves to any specific creed. The movement was joined by theoretically minded painters, such as Gleizes, Metzinger, André Lhote (1885–1962), but also by more spontaneous painters, like Roger de la Fresnaye

(1885–1925), whose works are among the most attractive if not the most original products of the group. The half-brothers Jacques Villon (1875–1963) and Marcel Duchamp (1887–1968) also made very personal contributions. Villon's paintings have been described as being composed of 'frozen light', and this well defines their crystalline beauty. Duchamp was interested in movement rather than light and came closer than any other French painter to the ideas of the Italian futurists, with their cult of the machine and their admiration for the speed of modern life. During the First World War he lived in New York, where, with Francis Picabia (1879–1953), he founded a branch of the Dadaist school which had arisen in Central Europe, largely as a reflection of the despair felt by intellectuals at the collapse of the old order of society. Dadaism, which in its original form was a purely destructive creed, never really took root in Paris, but was later to be of great importance in the formation of surrealism.

The 1914–18 war inevitably marked an interruption in artistic activity in France. Most of the leading artists were called up and, although Picasso and Gris, being neutrals, continued to paint, they did not make any revolutionary innovations. In the years immediately after the Peace of Versailles a number of new factors can be traced, of which perhaps the most important is the increased internationalism of the École de Paris, for up to 1914, with a few exceptions, all the leading figures in the school had been French, and Paris as a whole had been curiously unaware of, or aloof from, artistic movements in other countries, such as expressionism in Germany or futurism in Italy.

After the war certain groups of artists continued along the lines mapped out before 1914. One example of this was purism, which was in a sense a development of the *Section d'Or*. Under the leadership of Amédée Ozenfant (1886–1966) and Edouard Jeanneret (1887–1965), better known in the field of architecture as Le Corbusier, the purists emphasized the colder, more intellectual aspects of cubism, basing their art on an admiration for the machine. They were joined by Léger, who produced a series of paintings in which the clear colour and steely sharpness of machines are used as the raw material for compositions of great subtlety and harmony. Picasso's cubist paintings of the same years have analogies with the works of the purists, and even his great figure paintings of the period share with them the classical calm which characterized certain aspects of French culture at this time, notably the music of *Les Six*.

Purism was also of great importance in connection with architecture,

to which Le Corbusier applied many of the principles which he had learnt in connection with painting. Le Corbusier, who was Swiss by birth but lived in Paris from 1917 onwards, avoided the methods of training usual in architecture at the time, that is to say, study at the Beaux-Arts combined with apprenticeship in an architect's studio, but as a young man he met almost all the European architects of the older generation who were leading the way towards functionalism, and from them he learnt the foundations of his art. His own contribution was double: first a feeling for pure, simple forms and, secondly, a new and carefully reasoned conception of what was practically necessary in architecture in the twentieth century. Formally his buildings owe much to the principles of purism in the shapes and materials used and in the rejection of ornament. On the practical side he went far beyond his predecessors in town-planning, such as Tony Garnier (1869–1948) and the Italian Sant'Elia, because they worked out principles which were suitable for small units, whereas he planned for modern industrial cities with millions of inhabitants. His famous definition of a house as 'une machine pour vivre' was first applied to small houses in the suburbs of Paris (Villa Savoye, Poissy), but later to apartment blocks (Marseille) and public buildings (Maison Suisse, Cité Universitaire, Paris; Supreme Court, Chandigarh) and by extension to the designing of whole cities. His most celebrated work since the Second World War, the church of Notre-Dame-du-Haut at Ronchamp, is in a quite different vein, and the forms that the architect uses seem to be those of a surrealist sculptor rather than a purist architect.

The artistic scene in Paris in the 1920s was to a considerable extent affected by the fact that a number of artists from central and eastern Europe settled in France just before or just after the war and produced an infusion of quite different styles. Marc Chagall (b. 1887) brought with him from Russia via Germany an art which at its best employs Russian and Jewish symbols to create remarkable fantasies, but which often sinks into a mere whimsy, and Chaim Soutine (1894–1943) introduced a violent form of expressionism, partly based on the study of Van Gogh, which was quite contrary to the paintings of the School of Paris at the time.

In the middle-twenties the surrealists transformed the anti-rationalism of Dadaism into something more positive by asserting the supremacy of the imagination and the value of dreams, and of certain other non-rational phenomena, particularly automatic writing and drawing. Their theories probably applied more completely to literature than

to the visual arts, but certain painters, such as the German Max Ernst (b. 1891), the Spaniard Joan Miró (b. 1893), the Belgian René Magritte (1898–1967) and the Frenchman André Masson (b. 1896) produced paintings which fully expressed the doctrines of the school. Among the founder-members of the surrealist group was the Swiss sculptor and draughtsman Hans Arp (1887–1966), who had been an active Dadaist in Switzerland but settled in France in 1922, where he produced compositions built up of forms which, though non-representational, suggest organic growth. The surrealist painters admitted a debt to Picasso, and he was certainly influenced by their ideas in his *Three Dancers* (1925; Tate Gallery) and in his metamorphic paintings of 1929–30.

At the other extreme abstract art, originally an invention of Central and Eastern European artists, took a hold in Paris. Wassily Kandinsky (1866–1944), a Russian who had evolved an imaginative form of abstraction in Munich just before the war, and Piet Mondriaan (1872–1944), the leading Dutch abstract painter, both lived in Paris for some years, and the sculpture of the Romanian Constantin Brancusi (1876–1957) and the Russian Alexander Archipenko (1877–1964) enjoyed a sudden success. Artists who were French by birth did not, however, in general take kindly to abstract art, and the movement never really took root in Paris.

Some of the older artists who had been leaders in the creation of fauvism and cubism went on painting in modifications of their old style, but others continued to develop. The most conspicuous of these was Picasso, who in the thirties produced a new synthesis which combined the imaginative intensity of surrealism with a personal symbolism based on the bullfight to produce some of his most forceful paintings and engravings. Under the impulse of the Spanish Civil War he produced in *Guernica* (1937; Museum of Modern Art, New York) what could be considered the last great masterpiece in a long tradition of European paintings which commemorate through mythological, religious or historical symbolism the great tragedies of humanity.

The Second World War caused an even greater break than the first in the history of French art. Picasso continued to paint, and many of his works, notably the *Femme se coiffant* (1940), reflect the grimness of the situation in France under the German occupation. Other members of the older generation went on working in the provinces, particularly in the south of France before it was occupied by the Germans, but clearly the state of the country prevented the appearance of a new movement.

When after 1945 conditions began to return to normal, the position of the School of Paris had radically changed. The most important single factor affecting it was the rise of the School of New York. This was due partly to the fact that many Central European artists, who had taken refuge in Paris during the thirties, moved to America just before or during the war, but New York had also produced its own movement of abstract expressionism or action painting, created by Jackson Pollock (1912–56), which combined the automatism of surrealism with the vigour of expressionism. The sudden rise of the American School meant that for the first time in a century and a half Paris was no longer the artistic centre of the world, and the goal of young artists was New York.

It could be said that the vitality of the school had already begun to wane in the thirties, and it certainly lacked the buoyant confidence and energy of the *fauve* or cubist periods, but after the Second World War a certain feeling of actual provincialism crept into French art. It could be argued that Paris has made no real contribution to the development of new forms of art since 1945. Most of the painters who established reputations in the ten years after the war either were, like Alfred Manessier (b. 1911), 'Mannerists' producing variations on, or new combinations of, old styles, or, like Soulages (b. 1919) or Riopelle (b. 1924), used styles which were derived from other schools.

There have, of course, been exceptions. Nicolas de Staël (1914–51) produced what are perhaps the most luminous of abstract paintings, and Jean Dubuffet (b. 1901) developed a kind of fantasy painting which owes much to Paul Klee but is completely personal. On the whole however, great reputations have been made and high prices obtained by artists of quite minor talent, of whom Bernard Buffet is perhaps the most notable instance. In Paris, as in all parts of the world, dealers have played an increasingly important part in making or breaking young artists and in imposing their own, often arbitrary, tastes on the public.

Bibliography

There is no satisfactory single history of French art for the whole period from 1500 to the present day, but much of it is covered by the relevant volumes in the Pelican History of Art, all of which have full bibliographies: the present writer's *Art and Architecture in France 1500–1700*, 2nd ed. (1970), M. Levey and W. von Kalnein, *Art and Architecture of the Eighteenth Century in France* (1972), F. Novotny, *Painting and Sculpture in Europe 1780–1880* (1960), G. H. Hamilton, *Painting and Sculpture in Europe 1880–1940* (1967), R. Hitchcock, *Architecture: Nineteenth and Twentieth*

Centuries (1958). For architecture L. Hautecœur, *L'Histoire de l'architecture classique en France* (Paris, 1943; a revised edition is appearing) is a valuable book of reference for the period up to the mid-nineteenth century, though not always accurate in detail and with poor plates. The volumes by A. Châtelet and J. Thuillier, *La Peinture française de Fouquet à Poussin* (Geneva, 1963) and *La Peinture française de Le Nain à Fragonard* (Geneva, 1964), provide an excellent survey up to the late eighteenth century.

Much valuable information about all fields of French art in the sixteenth century is to be found in the catalogue of the exhibition 'L'École de Fontainebleau', held in the Grand Palais in 1972–3. For the painting of the period the reader should also consult Sylvie Béguin, *L'École de Fontainebleau* (Paris, 1960).

For the Caraveggesque party in French painting of the early seventeenth century the essential work is the catalogue of the exhibition *I Caravaggisti francesi* held in the Villa Medici, Rome, in 1973. For Vouet see further W. R. Crelly, *The Paintings of Simon Vouet* (New Haven and London, 1962), and for La Tour see B. Nicolson and C. Wright (London, 1974). For Poussin see A. Blunt, *Nicolas Poussin* (London, 1967–8) and W. Friedlaender and A. Blunt, *The Drawings of Nicolas Poussin* (London, 1939–74); and for Claude M. Roethlisberger, *Claude Lorrain: The Paintings* (London, 1961) and *Claude Lorrain: The Drawings* (Berkeley, 1968); for Lebrun the most useful document is the catalogue of the exhibition held at Versailles in 1963 (edited by Jacques Thuillier and Jennifer Montagu).

The architecture of the late sixteenth and early seventeenth centuries is well covered in R. Coope, *Salomon de Brosse and the Development of the Classical Style in French Architecture from 1565 to 1630* (London, 1972). For François Mansart see P. Smith and A. Braham, *François Mansart* (London, 1974). P. Verlet's *Versailles* (Paris, 1961) provides a convenient and reliable account of the complicated building history of that palace. His *Mobilier royal français* (Paris, 1955) is the standard work on French furniture of the pre-Revolutionary period.

The first half of the eighteenth century has been neglected by scholars of the twentieth century but much useful information is to be found in L. Dimier's unfinished *Les Peintres français du XVIIIe siècle* (Paris, 1928, 1930). For Watteau's paintings see J. Ferré, *Watteau* (Madrid, 1972), and for his drawings K. T. Parker and J. Mathey, *Antoine Watteau, catalogue complet de son œuvre dessinée* (Paris, 1957). A good short account of his work is given by A. Brookner, *Watteau* (London, 1967).

Useful monographs exist on the following artists: for Lancret, G. Wildenstein (Paris, 1924); for Pater, F. Ingersoll-Smouse (Paris, 1928); for Chardin, G. Wildenstein (Paris, 1933) and P. Rosenberg (Geneva, 1963); for C. J. Vernet, F. Ingersoll-Smouse (Paris, 1926); and for Greuze, A. Brookner (London, 1972).

For the taste of the mid-eighteenth century the essential document is Diderot's *Salons*, ed. J. Seznec (Oxford, 1957–67), but much can be gleaned from J. Locquin, *La Peinture d'histoire en France de 1747 à 1785* (Paris, 1912). There is still no satisfactory history of French sculpture in the eighteenth century, and for this and other aspects of French art of the period the most up-to-date information is to be found in the catalogues of the James A. de Rothschild collection at Waddesdon Manor – particularly *Sculpture* by T. Hodgkinson (Fribourg, 1970), *Sèvres Porcelain*

by S. Eriksen (Fribourg, 1968) and *Furniture* by G. de Bellaigue (Fribourg, 1974) - and the Wrightsman Collection, New York.

The most useful survey of neo-classicism is H. Honour's *Neo-classicism* (Harmondsworth, 1969) but the reader should also consult R. Rosenblum, *Transformations in Late 18th Century Art* (Princeton, 1967). Much detailed information and a good corpus of plates are to be found in the voluminous catalogue of the exhibition of neo-classical art held in London in 1972. For J. L. David see L. Hautecœur (Paris, 1954) and A. Brookner, *J. L. David: A Personal Interpretation* (London, 1974); and for Ingres, R. Rosenblum (London, 1967) and N. Schlenoff, *Ingres, ses sources littéraires* (Paris, 1956).

The literature on Romanticism is vast but of uneven quality. The best short survey is M. Brion's *Art of the Romantic Era* (London, 1966), but the reader should also consult Wakefield, *Stendhal and the Arts* (London, 1973) and *Charles Baudelaire critique d'art*, ed. C. Pichon (Paris, 1965). For Géricault see Clément (Paris, 1868) and L. E. A. Eitner, *Géricault's 'Raft of the Medusa'* (London, 1972). Delacroix's *Journal* and *Correspondance* have been published by A. Joubin (Paris, 1932 and 1935). For a general treatment of him as an artist see F. A. Trapp, *The Attainment of Delacroix* (Baltimore, 1971). T. Clark's *The Absolute Bourgeois* (London, 1973) and *The Image of the People* (London, 1973) give a stimulating account of the realist movement under the July Monarchy and the Second Republic. For Daumier see K. Maison (London, 1967–8) and for Courbet, Gerstle Mack (London, 1973).

The most complete accounts of impressionism and post-impressionism are J. Rewald, *The History of Impressionism* (New York, 1961) and *Post Impressionism* (New York, 1962). For neo-impressionism see R. L. Herbert, catalogue of the neo-impressionist exhibition at the Guggenheim Museum, New York, 1968. On symbolism see the catalogue of the exhibition *French Symbolist Painters* at the Hayward Gallery (London, 1973). Monographs exist on all the principal painters of the period as follows: for Manet, P. Jamot (Paris, 1932) and J. Richardson (London, 1958); for Monet, W. C. Seitz (London, 1960); for Degas, P. Cabanne (London, 1958); for Pissarro, L. R. Pissarro and L. Venturi (Paris, 1939); for Renoir, M. Drucker (Paris, 1949); for Cézanne, L. Venturi (Paris, 1937), M. Schapiro (New York, 1952), and the *Letters*, ed. J. Rewald (Paris, 1937–49, and London, 1941); for Gauguin, G. Wildenstein (Paris, 1964) and R. S. Goldwater (London, 1957); for Van Gogh, J. B. de la Faille (revised edition, 1970), and J. Leymarie (Paris, 1951) and the complete correspondence (New York, 1958); for Seurat, H. Dorra and J. Rewald (Paris, 1959) and J. Russell (London, 1965); for Toulouse-Lautrec, D. Cooper (London, 1955); for Moreau and Redon, J. Rewald and D. Ashton in the catalogue of the exhibition of Redon, Moreau and Bresdin (Museum of Modern Art, New York, 1962). For Henri Rousseau see J. Bouret (London, 1961); for Rodin, A. E. Elsen (New York, 1963); for Bonnard, J. and H. Dauberville (Paris, 1960) and J. Rewald (New York, 1948); for Vuillard, John Russell (London, 1971).

The best account of fauvism is to be found in J. Leymarie, *Le Fauvisme* (Geneva, 1959). For Matisse see his *Écrits sur l'art*, ed. D. Fourcade (Paris, 1972) and A. Barr (New York, 1951); for Derain, D. Sutton (London, 1959).

For an admirable survey of cubism see J. Golding (London, revised ed. 1968). Of the huge literature on Picasso the most useful biography is by R. Penrose (London, revised ed. 1971) and the best analysis of his work up to 1930 is by A.

Barr, *Picasso: Fifty Years of his Art* (New York, 1932). The most complete set of reproductions of his work is to be found in C. Zervos (Paris, 1932 – still appearing). For the most recent views on his art see *Picasso 1881–1973: Essays Edited by R. Penrose and J. Golding* (London, 1973). Monographs on the principal cubist and allied artists are as follows: on Braque, J. Leymarie (Geneva, 1961); on Gris, D. H. Kahnweiler (London, revised ed. 1969); on Léger, R. L. Delevoy (London, 1962). For Brancusi see the catalogue of the exhibition at the Guggenheim Museum, New York, 1965, by S. Geist. For purism see the catalogue of the exhibition of Léger and purist Paris at the Tate Gallery, 1970 (J. Golding and C. Green). For Orphism, V. Spate (Oxford, to appear in 1975). For Le Corbusier see C. Jencks (London, 1973).

For Dadaism and surrealism see W. S. Rubin, *Dada, Surrealism and their Heritage* (New York, 1968), M. Sanouillet, *Dada à Paris* (Paris, 1962), and Marcel Jean, *History of Surrealist Painting*, English ed. (London, 1960). For Miró see J. Dupin (Paris, 1962).

For Chagal see F. Meyer (London, 1964) and for Duchamp, R. Lebel (London, 1959).

FRENCH MUSIC

1500–1950

Edward Lockspeiser

'Tout finit par des chansons,' says Beaumarchais in *Le Mariage de Figaro*. One is not altogether sure that civilization will expire in song – unfortunately something more sinister is nowadays indicated – but civilization certainly bursts forth in song. Song, the most primitive form of human communication and of which all other music is merely an imitation, has proclaimed at all times the birth of a musical civilization. So it was in medieval France. Beaumarchais could not have been aware of the national heritage of the troubadours and trouvères, nor of the mysteries of Gregorian chant. Musicians in his time were not yet orientated towards historical research, and therefore Beaumarchais, astute observer as he was, did not perceive that France, together with England, had led the way in European musical civilization from the twelfth century onwards. The most sensitive poetry in Europe had been that in the *langue d'oc* and the *langue d'oïl*. France had seen the rise of a school of sculpture unsurpassed in beauty of expression since the Greeks. Now she was to produce two marvels of civilization: Gothic architecture and musical polyphony. The two twelfth-century masters of the Notre-Dame school of musical polyphony, from which our Western notion of harmony springs, were Léonin and Pérotin le Grand. It is at this point that French musical history begins to unfold.

Obviously, every aspect of music in France cannot possibly be embraced in a single study, however wide the scope of one's inquiry. If we are to absorb history at all it must be selective. The historian must interpret. What then marks the musical tradition stretched across eight centuries from Pérotin to Poulenc? The parallels in the adjacent spheres of poetry and painting, the reflections in these spheres and the analogies. Music was also calculated to fertilize the artistic mind on many different planes. Ronsard, Delacroix and Debussy are typical of

the figures who saw poetry, painting and music cross-fertilized in this way.

The French are the thinkers in music. They are the musical philosophers, sometimes the musical mathematicians, also the musical dramatists. 'La musique doit humblement chercher à plaire' is a statement attributed to Debussy. They are the hedonists of music. Yet what are the qualifications of a French composer? What is his ancestry? He is not necessarily a native-born musician. The French have not only absorbed ideas from foreign traditions – in this sense they are the internationalists of the musical world; they seem to make a point of incorporating within the national tradition alien figures who do in fact open up distinctively national provinces. Lully, an Italian, created the French tragic opera; Offenbach, a German, established the Parisian operetta; and the most influential musical style of the twentieth century was the discovery of Stravinsky, a naturalized Frenchman.

A historian is not only required to interpret; he must throw colliding developments boldly into relief. Certainly, the many tributaries in the French musical landscape are sometimes as profitable to pursue as the broad mainstreams. Backwaters, therefore, will not be forgotten in this rapid survey, nor, when the temptation to linger is irresistible, will the single illuminating work of genius.

The Renaissance

The chansons of Clément Janequin (c. 1480–c. 1560) use musical symbols and realistic effects in a broad descriptive manner. A figure of wide popularity, Janequin was inspired by battle sounds, hunting scenes, birdsongs and even the shrill chatter at a hen party ('Le Caquet des femmes'). In 'La Bataille de Marignan', about the battle fought by François I in 1515 against the Milanese, the music imitates fanfares and drum beats. Ingenious rhythmic effects simulate battle sounds, and indeed much of this large-scale work is purely onomatopoeic. *Pata pan, pan pan* sing the altos in this battle scene: a surprise attack provoking a counterblast from the sopranos, *trique trac, trac, zin, zin, zin*. 'L'Alouette' includes a realistic lark-song. In 'Le Chant des oiseaux' there is a playful allusion to the habits of the cuckoo. 'Pour quoy tournés vous vos yeux', 'Ce moys de mai' and 'Qu'est-ce d'amour' are other titles of Janequin's 286 chansons, many of them purely lyrical. Ronsard, Clément Marot and François I himself were among the poets he drew upon. Material from the first part of 'La Bataille de Marignan' was

incorporated by Janequin in a sacred mass. Another of his masses is
based on the secular chanson 'L'Aveuglé Dieu'. Sixteenth-century
publications of Janequin's sacred music include his *Sacrae cantiones* and
his *Proverbes de Solomon* which, however, survive in an incomplete
form.

Claudin de Sermisy (*c.* 1490–1562), one of the principal composers
of masses, motets and chansons of the Renaissance, served at the court
of François I. He was among the musicians who delighted the public
at the meeting between Henry VIII and François I at the Field of the
Cloth of Gold (1520). His chansons, including a setting of Petrarch,
sometimes show traces of the Italian style. This indicates that the French
court was not only open to the influence of Leonardo da Vinci and the
painters of his time but that it was ready to absorb the influence of
contemporary Italian musicians. Claudin's music, however, remains
distinctively French. It is predominantly chordal, it is lyrical, and the
textures are light and airy. He also writes in a vivacious manner using
rapidly repeated notes. Over 200 chansons of Claudin, among them his
widely performed 'Jouissance vous donneray', appear in collections of
the period. He acquired a reputation beyond the sphere of court
musicians, as one sees from the fact that he is mentioned in Ronsard's
Livre de meslanges and in Rabelais's *Pantagruel* (Book 4).

Claudin's music marks the triumph of simplicity. Straightforward
rhythms and contrapuntal devices replace the technical complexities
of earlier periods. Many of his chansons, including his 'Secourés-
moy' and 'D'où vient cela', settings of poems by Clément Marot, follow
the *a b a* form or variations of it. The phrases of these chansons are
well defined and the form is clear-cut. These are qualities, incidentally,
which allowed Claudin's vocal works to be published in an instru-
mental form. In common with his Italian contemporaries, he was
aware of the subtlety of colouring in the four voices.

A member of the Sainte Chapelle, Claudin wrote much sacred
music. Here again Renaissance historians stress the uncomplicated nature
of his style. In his *Missa plurium mottetorum* he writes for voices in pairs
and uses a simple note-against-note counterpoint in parallel motion.
Melodies are short, wide intervals are avoided and, as in his secular
works, chordal effects produce a consistently clear texture. His seldom
performed Requiem and motets are similarly said to display this virgin
simplicity. Only occasionally is there a mystifying element in Claudin's
work. In his curious *St Matthew Passion* Judas is impersonated by a four-
part choir while the words of Pilate's wife are sung by a male quartet.

Earlier critics likened the appeal of Janequin's music to that of a fresco, and indeed this image appropriately suggests the varied scenic character of his large-scale chansons. With Claudin, Janequin established a distinctively Parisian school of the chanson, a sophisticated school with a provincial outpost at Lyon. As in the Middle Ages, Paris under the Valois became again one of the great European musical centres. Minor figures of this Paris school wrote many delightful works in a light style. They include Pierre Certon, the composer of a witty chanson entitled 'La, la, la, je ne l'ose dire', Passereau whose descriptive chanson 'Il est bel et bon' reproduces the cackle of hens and the calls of other farmyard creatures, Pierre Sandrin known for his chanson 'Douce mémoire', and Hesdin, the composer of 'Ramonez moy ma cheminée'. Descriptive chansons were written by Nicolas Gombert (c. 1500–c. 1556). His 'Chant des oiseaux' uses the same text and thematic material as Janequin's *Bird Song* though Gombert's technical procedures are more intricate. In other chansons he uses highly involved technical methods. They include the chanson 'En l'ombre d'ung buissonet' in the form of a triple canon, and 'Qui ne l'aymerait' using a quadruple canon.

The French and Italian musicians interacted upon each other. The French chanson assimilated Italian methods and, in its early stages, the Italian madrigal was inspired by the methods of the French chanson known in Italy as the *canzona alla francese*. Composers of the madrigal were often concerned with word-painting, that is to say a representation of the text in musical symbolism. Gustave Reese carries this argument further. 'The madrigal', he says, 'came to be a genuine, small *Gesamtkunstwerk*, going so far as to include visual elements, yielded by "eye-music" procedures.'

An important figure in the early history of the madrigal is Philippe Verdelot, said to be a Frenchman by Vasari in his *Lives of the Painters*, and who spent many years in Venice and Florence. Apart from the visual appeal of the madrigal, various attempts were made in the sixteenth century to coordinate the aims of music and poetry. In 1549 Joachim Du Bellay published his *Défense et illustration de la langue française* which, together with Ronsard's *Abrégé de l'art poétique français* (1565), formed the poetic manifesto of the Pléiade. Their ideal was a type of poetry susceptible to a musical setting with lute accompaniment. Jean Antoine de Baïf, on the other hand, advocated the rules of classical prosody. He produced a system known as the *vers mesurés à l'antique* based on the long and short quantities characteristic of French

syllables in the spoken language. Together with Ronsard Baïf founded, under the patronage of Charles II, the Académie de Poésie et Musique designed to establish a closer union between the arts.

The principal figure to emerge from Baïf's Académie was Claude Le Jeune (c. 1530–1600). In his settings of chansonettes by Baïf entitled *Le Printemps* Le Jeune was able to bring life and inspiration to these academic devices. But he appears to have been primarily interested in technical problems. In his chanson 'Qu'est devenu ce bel œil' he uses chromatic effects borrowed from the Italian school. Other works of Le Jeune reveal his attraction to Calvinist ideals. He also wrote large-scale chansons, one of them in the printed version running to over sixty pages. This union of poetry and music was, however, of temporary duration. Eustache Du Caurroy (1549–1609) was among the last composers of *musique mesurée*.

The Reformation produced the Huguenot Psalter of 1561. Verses by Clément Marot and Théodore de Bèze were set to secular or folk tunes. These Huguenot Psalms were designed to be sung by the entire congregation, and most of them are therefore rudimentary and of little artistic interest. Exceptions were the Psalms of Charles Goudimel (c. 1520–72)´ who embodied the austere spirit of the Reformation, Claude Le Jeune and Jacques Mauduit (1557–1627). Calvin, in fact, in accordance with the severer Protestant philosophy, realized both the power and the dangers of music. It should serve only 'honest purposes', he declared. Possibly with the licentious character of certain French chansons in mind, he maintained that music should 'not open the way to dissoluteness or unrestricted delights'. Many religious adaptations of secular or even operatic songs were made by both Protestants and Catholics. Lully, recognizing one of his operatic arias adapted for religious purposes, exclaimed aghast: 'Forgive me, O God, this was not written for Thee.' The *Noëls* came into vogue during the sixteenth century. Two works by Guillaume Costeley (c. 1531–1606), 'Allons, gay, gay, gay bergères' and 'Sus debout gentils pasteurs' are outstanding models of this genre.

Costeley is believed to have organized the Confraternity of St Cecilia at Évreux in 1570 where he held the rank of 'prince'. This was a festival celebrating the saint's day with performances of sacred music. A court musician who was organist to Charles IX, Costeley published a book of chansons in 1570 which remains one of the most exquisite products of the French Renaissance. His 'Las je n'yrai plus jouer au boys' is written in a parlando style of wonderful lightness wholly in keeping

with the aesthetic of Couperin and Rameau, and indeed of Fauré and Debussy. Fully aware of his originality, he dedicated one of his publications to Charles IX with the inscription:

> Va donc mon Labeur, suy tous ceux qui t'aimeront:
> Je voy bien que tu crains quelque cérémonie,
> Va, va, ne t'esbahy de ceux-là qui diront:
> 'Ce Costeley n'a pas d'un tel le contrepoint',
> Il n'a pas de cestuy la pareille harmonie,
> J'ay quelque chose aussi que tous les deux n'ont point.

The supreme master of the French Renaissance was not a Frenchman but a Walloon from the Hainault. Roland de Lassus, or Orlando di Lasso as he is better known in the Italian form of his name, was born in 1532, possibly at Mons, and died at Munich in 1594. Little is known of his youth apart from the fact that he was in the service of Ferdinand Gonzago, Viceroy of Sicily, between the ages of thirteen and seventeen. In 1556 he was engaged at the ducal court of Albert V at Munich. He maintained a close relationship with the Italian school and made six journeys to Italy between 1565 and 1587. His works were first published at Antwerp and Venice. Thereafter he acquired a European reputation. As a composer of motets, madrigals, French chansons, villanelles, as well as masses and other forms of religious music, he was courted by the great publishing houses throughout the civilized world. In 1571 he visited Paris where his works were widely appreciated. He acquired during his lifetime many titles of praise, among them *Orpheus belgicus, mirabile Orlando,* and *le plus que divin Orlande.* Orlando was the master of the French Renaissance but he was also the last of a line of great international musicians, one of whom, a century earlier, was Josquin Desprès. Though many dialects are used in his correspondence, his mother tongue was French and it was in French that he corresponded with his patron, the Duke of Bavaria. Moreover, his familiarity with this language is evident from his wonderful settings of French texts, in particular the poems of his beloved Clément Marot.

Orlando's chansons embrace many different genres. Symbolical methods are illustrated in the opening bars of 'J'ay cherché la science' where 'a search for knowledge' is represented by inversions of a fugal theme. In 'Fuyons tous d'amour le jeu' two themes combined in imitation are calculated to convey the idea of a flight from love. Another realistic effect is a contrapuntal picture of 'a rope-maker untwisting his rope'. The Italian style, on the other hand, is evident in the

setting of Du Bellay's text, 'La nuict froide et sombre'. At the close
the music evokes the light of dawn gradually illuminating the land-
scape.

Elsewhere Orlando's methods are inspired by a broad sense of
humour. 'En m'oyant chanter' presents the solmization exercises of an
amateur singer. Single words often inspire a precisc musical image. The
singer, about to enunciate the word *soupirer*, is required to catch his
breath on the preceding rest to simulate the pangs of love. Sometimes
the secular and the religious styles are contrasted in a burlesque manner,
as in the setting of Marot's poem 'Il estoit une religieuse'. In the amusing
chanson in the style of the Paris school, 'Quand mon mari', a young
wife complains that her grumbling spouse is ready either to scold her
or to assault her with a kitchen spoon. The music illustrates every detail
of this painful domestic scene down to its melancholy conclusion,
'Je suis jeune et il est vieux'. Many of Orlando's chansons enjoyed
immense popularity, among them 'Susanne un jour' on the subject of
Susanna and the Elders. Some of his 140 chansons were reprinted by
Huguenot publishers who replaced the original poetic or amorous
verses by texts of a severely moral appeal. 'Mon cœur se recommande
à vous' thus becomes, in a Huguenot version, 'Mon cœur se rend à toy,
Seigneur'.

Seventeenth-Century Ballet and Opera

In the seventeenth century the ballet took its rise. At the same time
two musical forms predominate, the court air (the *air de cour*) and the
chanson for solo voice. At the French court a distinction was drawn
between vocal and instrumental composers. Henri IV promoted vocal
music, also music for the lute and spinet and the production of ballets.
The court air was often in the form of a dialogue between a soloist
and accompanying voices, a procedure used also by Monteverdi in his
arie alla francese. These airs, remarkable for their rhythmic freedom,
were often written out without bar lines. Pierre Guédron, Antoine
Boësset and Estienne Moulinié were among the principal composers
of this aristocratic form which marked, according to Henry Prunières,
'a triumph of a sensuous, hedonistic aesthetic to which the French
long remain attached'. The chanson for solo voice was a popular
form throughout the sixteenth century, and it has indeed remained
in favour down to the present day. Later forms of the chanson were
known as *voix de ville* or vaudeville, and it is clear enough that the

vogue of the popular song in the twentieth century is at any rate partially rooted in this seventeenth-century form.

Vocal music in the seventeenth century was associated with four so-called noble instruments – the lute, the harpsichord, the spinet and the viol. The French seventeenth-century lute, a much larger instrument than the earlier Renaissance lute, drew from the musically-minded an almost romantic response. A contemporary memoir evokes these early transports:

When a good man takes the instrument and, trying out his strings and chords, sits on a corner of the table seeking his fantasy, he will no sooner have plucked his strings three times and started the tune than the eyes and ears of everyone are upon him. Should he wish the strings to languish under his fingers his audience is transported, charmed by a sweet melancholy. Then one drops his chin on to his chest, another props it up with his hand; another shamefully stretches right out as if he were being pulled by the ear; and there is one with eyes wide open and mouth agape, as if his mind were pinned to the strings. You would say that these people have no other sense than hearing; that their soul itself dwelt in their ears so as to enjoy un-troubled this intense harmony. Then the playing changes, life is given to the strings, and immediately the feelings of everyone are astonishingly aroused; for the player can do with men what he wishes.[1]

The French genius of the lute was personified by Ennemond Gaultier (le vieux Gaultier, d. 1653) who wrote compositions of a grave character entitled *Les Tombeaux* and *Les Larmes*. Early composers for the harpsichord reproduced the lute's varied rhythms and arpeggio basses. The harpsichord was at first an imitation lute. It was only later in the works of Chambonnières and Louis Couperin that the individual keyboard character of the harpsichord was established.

An aristocratic form of great historical importance was the court ballet. It is true that before the advent of Lully the musical value of the court ballet was altogether inferior. The music was conventional in the extreme and of an anonymous character. In modern times none of it has been revived. Yet the spectacle of the court ballet, its theatrical impact, made a great appeal to musical minds. It opened the way to the

[1] See Henry Prunières, *A New History of Music*, translated from the French and edited by Edward Lockspeiser (New York, 1943), p. 256.

French conception of grand opera. The court ballet usually opened with a majestic overture. Towards the end of the spectacle the musicians of the Royal Chamber appeared, and finally the king himself accompanied by the princes of the blood. Dressed in satin and brocade, their faces covered by gold or black masks, and wearing the buskins of the Athenian tragic actors, they performed a figure ballet in a sixteenth-century style. Later, under Louis XIII, the ballet became an extravagant masquerade. Exotic elements were introduced. The characters in the ballet were now Spaniards, Indians and Negroes, and the performing animals included elephants and llamas.

The founder of French opera, Jean-Baptiste Lully (1632-87), was a product of this court ballet. Born in Florence, Lully came to France at the age of fourteen and later entered the service of Louis XIV as a buffoon. He was also a talented violinist and dancer. He studied composition in France and his earliest works were written in both the French and the Italian styles. Obviously he was a many-sided personality. He introduced vocal music into the ballet and some of his dramatic scenes foreshadow an operatic treatment. He also created an early form of the operatic overture. This was the so-called French overture in three sections (a *grave* movement leading to a lively fugue and followed by a slow coda). In the *Ballet des Muses* (1668) he appeared on the stage dressed as Orpheus and performed a concerto which he had written for violin and orchestra.

Lully's collaboration between 1664 and 1671 with Molière produced the *comédie-ballet*. This was a theatrical entertainment containing elements of the later French forms of dramatic opera and the *opéra-comique*. Henry Prunières, the leading authority on this period, believes that Molière played only a relatively minor part in these *comédies-ballets*. It appears that not only the music but some of the comic texts in *Le Bourgeois Gentilhomme* and *Monsieur de Pourceaugnac* were the creations of Lully unaided. In 1673 Lully wrote *Cadmus et Hermione*, the first of his fifteen *Tragédies en musique* on librettos by Philippe Quinault and others. Here the vocal writing was inspired by the song-like recitations of La Champmeslé, the great actress in the tragedies of Racine. Lully's use of the orchestra similarly broke new ground. Using a variety of orchestral methods, he was able to portray many typical scenes of the seventeenth-century theatre – a magic garden, a tempest, as well as scenes of battle and sacrifice. The operas of Lully were widely acclaimed in his day, and in fact held the stage in France and other countries for more than half a century.

The Harpsichord School

François Couperin (1668–1733), known as Couperin le Grand, belonged to a famous dynasty of organists, harpsichordists and composers. There are in all twelve members of this dynasty extending from the seventeenth to the nineteenth centuries. Couperin showed an almost Mozartian precocity for at the age of eleven he was promised his father's post as organist. Later he was appointed organist at the Chapel Royal and became harpsichord teacher to several noble families. His life was on the whole uneventful. In 1715 he abandoned sacred music in favour of chamber music of which he published several volumes, though his secular works were seldom performed during his lifetime. He died almost forgotten and remained undiscovered for over a century. Influenced in his youth by the vigorous Italian manner of Corelli, he later attempted to combine this full-blooded style with native traditions of grace and irony. Hence such titles of his works as *Les Goûts réunis* and the *Apothéoses* of Corelli and Lully. An indication of the intensity of his lyrical sense is evident from his motto: 'J'avoue que j'aime beaucoup mieux ce qui me touche que ce qui me surprend.' In fact there is some kind of romantic nostalgia underlying this ordered classical music, notably in the famous B minor *Passacaille* for harpsichord which suggests the keyboard manner of Chopin and at the same time the severity and restraint of Racine and La Fontaine. Dating from the end of his life, the trio and quartet sonatas sometimes attain the grandeur of Bach while his *Leçons de ténèbres* are among the greatest religious works of all time. Couperin is, however, best known for his harpsichord pieces, a reputation largely created by the ironic titles which Couperin attached to these pieces (*Les Baricades mistérieuses*) and which thus encouraged the young ladies who performed his music to see only its picturesque side. On the technical plane Couperin was above all the master of harpsichord ornamentation. His innovations in the form of turns and mordants were also used by Bach and were later incorporated in the melodic language of the nineteenth century. Some of his pieces in a nervous, vivacious manner, such as *Les Timbres* and *Les Tricoteuses*, look forward to the swift-moving music of Debussy in this style. Elsewhere, in his burlesque pieces, such as the extraordinary *Pantomime*, Couperin appears as a precursor of Ravel. Forgotten during the nineteenth century, at any rate in France, Couperin was revived during the age of Debussy and Ravel who saw him as a forward-looking, exploratory artist. Debussy considered that

Couperin was one of the great *devineurs* of music, an opinion with which Ravel, the composer of *Le Tombeau de Couperin*, would certainly have concurred. Not for nothing are mysterious, almost mystical qualities nowadays ascribed to this master of the French classical tradition.

Jean-Philippe Rameau (1683–1764), the most important French composer of operas in the eighteenth century and the first great musical theorist of modern times, originally came before the public as a harpsichord composer. During the greater part of his career he was a church organist in Paris, Dijon and Lyon. Towards the end of his life, however, he was engaged as conductor of the chamber orchestra at the Paris home of La Pouplinière. There he met Voltaire whose spirit he sometimes reflects and who supplied him with the libretto of his first opera *Samson* which, unfortunately, was never performed. It was only when he was fifty that an opera of Rameau, *Hippolyte et Aricie*, was first produced. Thereafter, until his death, he produced an unending flow of lyrical tragedies, opera-ballets and pastorales, an amazing phenomenon in itself yet which was all the more remarkable since Rameau, prompted by his discussions with Jean-Jacques Rousseau and d'Alembert, had been devoting himself more and more to theoretical works on music. Though he wrote little for the harpsichord he nevertheless made a stylistic contribution to harpsichord music on the level of that of Bach, Couperin and Scarlatti. Dramatic qualities are evident in his works, notably in *La Poule*, and he is aware in the harpsichord not so much of the dry, plucked sound (*le tin tin du clavecin*) but of a continuity and evocation of sound, almost as if he were writing for the piano.

Rameau's lyrical tragedies derive from the style of the tragedies of Lully just as the dramatic works of Voltaire derive from those of Racine. *Hippolyte et Aricie*, revived with other dramatic works of Rameau in the twentieth century, shows a great vocal and instrumental advance on the operas of Lully. *Castor et Pollux* reveals another aspect of his genius. The music is not primarily inspired by the dramatic action; it is designed to suggest the inner nature of his operatic characters. In *Platée* a comic element is introduced, while *Dardanus* has a grandeur recalling the poetry of Racine. The revival of *Les Indes galantes* at the Paris Opéra after the Second World War brought to life again the eighteenth-century form of the *opéra-ballet*.

Among his theoretical works Rameau's *Traité d'harmonie* (1722) establishes the nature of harmony based for the first time on theories of acoustics. It is thus the first theoretical work on music foreshadowing

the scientific conception of sound in the twentieth century. Rameau was concerned with chords, with consonant and dissonant chords, rather than with scales. He was not interested in the succession of notes in the form of a melody in time. He saw music vertically rather than horizontally; he saw it in depth too, and was aware of something approaching a musical perspective. Consequently he was interested in the 'inversions' of chords, in the groupings of notes sounded simultaneously and in the rearrangement of these elements of a chord so that different notes appear in the bass. Instinct guided him in the distinction between consonance and dissonance. The fact is that once the principle of dissonance is admitted into harmony, that is to say a dissonance in the form of an ordered clash, 'prepared' in the listener's mind and ultimately 'resolved', music is seen to resemble a logical discourse. Reason at last becomes music. Shape, structure and a rational conception of harmony were henceforth to be the elements of composition, so that in these theories springing from the logic and the philosophy of the Encyclopedists, the foundations were laid for those wonderfully abstract combinations of harmony and perspective in the eighteenth century, namely the classical sonata forms of Haydn and Mozart.

Character portraits of Rameau are unfortunately lacking. A thumbnail sketch of him by Henry Prunières ('this terrible miser who had the head of Voltaire, but without his smile nor the look in his eyes') nevertheless reveals something of his nature:

> He was a strange personality, this tall, gaunt, long-legged man in skimpy clothes, lost in his dreams as he walked about the town. He was not kind-hearted; nor was he malicious. To everything except his art – and also his money which he piled into coffers though he lived like a pauper – he was indifferent. His wife was a sweet-natured obedient woman, and his daughter married only after his death. Generosity was not unknown to him, but he was feared, not to say dreaded, by everyone. The curé who administered his last sacraments was sharply reprimanded for singing out of tune.[1]

Despite their musical invention, Rameau's later operas were held to be undramatic, even during his lifetime. In our age of the mechanical reproduction of music, when the whole panorama of musical history is ceaselessly unfolded before us, revivals of the operas of Rameau and

[1] Henry Prunières, *A New History of Music*, p. 285.

his contemporaries are not excluded. Nevertheless audiences who respond to Verdi and Wagner will probably endorse Voltaire's ironic appraisement of the operas of his time:

> The Opera is a spectacle as outlandish as it is magnificent, where the eye and the ear are more satisfied than the mind, where the fact that everything has to be set to music causes the most ridiculous situations, where they sing while a town is being destroyed and dance around a tomb; where one sees the palaces of Pluto and the Sun; gods, demons, magicians, marvels, monsters and palaces rising before one and destroyed in the twinkling of an eye. One suffers, nay, enjoys these extravagances, because this is fairyland; and so long as there is some display, good dances, beautiful music and a few interesting scenes one is pleased enough.[1]

Classical and Romantic Opera

The composer who built a bridge between the lyrical tragedies of Lully and early nineteenth-century opera was Gluck. Though born in Germany, Christoph Willibald Gluck (1714–87) achieved his greatest successes in Paris where at the end of his life he produced *Iphigénie en Aulide* on a text based on Racine, *Orphée et Eurydice* (both 1774), *Alceste* (1776), *Armide* (1777) and *Iphigénie en Tauride* (1779). Most of Gluck's other operas are forgotten, but these works, written for production at the Académie Royale in Paris, show the lyrical tragedy of Lully and Rameau brought to perfection. The recitative is replaced by broad melodic phrases, the harpsichord is dispensed with and the orchestra accompanies both the arias and the new style of the recitation. Undesirable breaks in passages of lyrical declamation are avoided. Themes developed in the overture foreshadow the drama. The Romantic era is within sight, and indeed Wagner considered that the first use of the leitmotive was in Gluck's overture to *Iphigénie*. Gluck had entered the Promised Land. Not for nothing did Mademoiselle de Lespinasse declare that Gluck's *Orphée* was 'so profound and moving, so heartrending and so engrossing that it was absolutely impossible for me to speak of what I had experienced.'

All the composers of the period of the French Revolution were more or less faithful disciples of Gluck. Orchestral colour begins to be a means of expression and with it a chromatic sense of harmony. Étienne

1 Ibid., p. 286.

Nicolas Méhul (1763–1817) wrote two successful operas under Gluck's influence, *Le Jeune Henri*, the overture of which is still played, and *Joseph*. Jean-François Lesueur (1760–1837) adapted the technique of Gluck to the nineteenth-century notions of programme music. His principal operas were *La Caverne* and *Les Bardes*. Admired by Napoleon, Lesueur proclaimed that music should be capable of evoking associations of a storm or an earthquake. He may have been exaggerating. Yet it is easy to see how these ideas influenced the style of his most famous pupil, Berlioz. As we know, Berlioz himself carried forward the Gluck tradition which had earlier been developed in this pictorial fashion by Lesueur. Luigi Cherubini, who was born in Florence in 1760 and died in Paris 1842, was another composer favoured by Napoleon. His opera *Médée* announces the Romantic era. In some of these French works of the Napoleonic era the style is foreseen of Beethoven who in fact was one of Cherubini's warmest admirers. Auber and Boieldieu are other opera composers bridging the eighteenth and nineteenth centuries. Despite the brilliance of the earlier instrumental and vocal schools, it was long held that a composer in France was not a composer at all unless he were an operatic composer. Even in the middle of the nineteenth century, Ambroise Thomas, the director of the Conservatoire, declared, to the horror of his students brought up on the symphonies of Haydn, Mozart and Beethoven: 'I teach opera but I would never condescend to teach symphony.'

Romantic Ideals

Romanticism is a term which hardly allows a precise definition. Too many contradictory elements are included in this eruptive movement. Yet if there is a single figure who does bring together and characterize the Romantic spirit that explodes in music, literature and painting, then Hector Berlioz (1803–69) must be this commanding figure. Musically, Berlioz is a descendant of Gluck. He was inspired also by the large-scale Revolutionary works, performed in the open air and therefore rather bland in character – often they were in C major – by his master Lesueur and other Napoleonic composers. From Beethoven Berlioz learnt the 'heroic' style. The great moments in the *Symphonie fantastique* and *Les Troyens* could not have reached their heights without this Beethoven influence. On the other hand, Berlioz seems to have been uncritical of Beethoven's leanings to the pompous style, e.g. in the Finale of the Fifth Symphony. We may have difficulty

today in seeing Berlioz as a descendant of Gluck, for indeed two worlds appear to face each other in Gluck's severely classical operas and the volcanic overtures and symphonies of Berlioz. The fact is that a new field of the musical mind had been explored, the field of orchestral colour. The orchestra becomes a means of expression in itself. Berlioz, more than Gluck, certainly more than Lesueur, even more than Beethoven, proclaims the new colour sense in music. Only Weber, the darling of Baudelaire, equals him here. Weber marks out the whole subsequent development of orchestral colour, his disciples including Bizet and Messiaen.

Berlioz has not only a remarkable pictorial sense in music. He has a wonderfully suggestive manner of evoking a scene or a vision; he can create an atmosphere with beautifully judged effects. This is why the scenes of the storm and the Royal Hunt in *Les Troyens*, with its extraordinary horn solo, and of the Roman Carnival in *Benvenuto Cellini*, with its unrelenting rhythm on strings and drums, make such an unforgettable effect. They are among the great examples of descriptive music in the nineteenth century. But he is uneven. Though he had an original sense of the orchestra and wrote pages that show some kind of fire of the mind, his sense of psychology in opera was weak. His characters are cardboard affairs. They seldom come to life. Also, he had a curious idea of melody. His tunes are gawky and angular, in fact artificial, as if a wire had been run through them. And his softer lyrical music is dry. His slow-moving music lacks sensuousness; it has no bloom on it. Perhaps the trouble is that in a nation of opera composers Berlioz by temperament was unsuited to compete in this form. His field of activity was the concert hall. Contemporary critics rightly called his works *opéras de concert*.

It is one of the commonplaces of musical criticism that alone in England has the genius of Berlioz been discovered, rightly assessed and justly proclaimed. The French, ignorant and blasé, according to the banner-bearers of the rather wild sect devoted to this composer, have unjustly neglected the greatest of their Romantic composers. ('Who is our greatest composer?' one hears the well-informed French critics murmuring, in imitation of André Gide. 'Berlioz, hélas!') In England no superlative could do justice to this mighty figure. A race of gloriously intemperate Berlioz fanatics declared that Berlioz was a genius of the stature of Beethoven, of Wagner, greater than Wagner. I think we may see now that Berlioz's English admirers between the two World Wars, reacting against the prolonged influence of Wagner, were casting about

for an 'anti-Wagner'. This was the role which, with some justification, they ascribed to Berlioz. But it was an old-fashioned notion, dating from the time when Berlioz and Wagner appeared to be at logger-heads. In fact Berlioz, like his contemporary Baudelaire, was an ad-mirer of *Tannhäuser* and *Lohengrin* but not of the Prelude to *Tristan* which he likened to an impossible 'chromatic groan'.

Berlioz also gives to music its personal imprint. The character, the man, the style stand out in his works. Musicians, however, are not always drawn to psychological ideas. Underlying motives prompting an artist's work, his cast of mind or even his physical appearance frequently enter the spheres of art criticism. Music criticism approaches these human associations with difficulty, and it thus comes about that many of Berlioz's biographers have left the composer curiously estranged from his work. Perhaps this is due to a certain play-acting element in Berlioz's character and to his compulsion, common to men of genius, to create out of his life a legend. Such artists, unlike their biographers, see themselves with surprising clarity. There is a merciless analysis of this mechanism in the character of Samuel Cramer, Baudel-aire's self-portrait in his tale *Le Fanfarlo*:

> A gentleman by birth, taking on the airs of a scoundrel – by tem-perament he was an actor – he played behind closed doors unbeliev-able tragedies, or rather tragi-comedies. If possessed by a gentle spirit of mirth, he must nevertheless clearly establish this fact and proceed to train himself to explode in peals of laughter. A moist eye might reflect an awakened memory, whereupon he would watch himself in the mirror pouring forth floods of tears. Responding to the childish jealousy of a girl scratching him with a needle or a penknife, Samuel must glorify this episode by stabbing himself; or if he owed the wretched sum of twenty thousand francs, he would joyously proclaim 'What a sad lot is that of a genius plagued by the debt of a million francs'.

Where have we read scenes of this kind before? Again and again, of course, in Berlioz's irresistible *Memoirs*. The cults of pleasure and ad-venture were shared with Baudelaire, also an indulgence in unfathom-able boredom, our old friend the Romantic *ennui*. Baudelaire's ideals were the vices of poison, rape and arson. Berlioz, a fraternal diabolist, proclaims himself 'an Attila ravaging the musical world, a revolutionary to be guillotined'. Disillusionment ultimately engulfs their worlds in a vast yawn, and the famous sardonic line that Baudelaire implants in the

mind of the reader of the *Fleurs du mal* may similarly light up the enig-
matic genius of Berlioz himself. 'Hypocrite lecteur, – mon semblable,
– mon frère!'

The Cult of the Individual

The French Romantic movement in music may not show the emo-
tional profundity of the contemporary German movement. There are
no composers of the stature of Beethoven and Wagner in French music.
But musical Romanticism nevertheless requires each artist to be a law
unto himself. The main demand we make of an artist, according to the
Romantic philosophy is, 'Does he create a world?' Ideas of harmony and
colour in Berlioz and Bizet, for instance, are wholly dissimilar, despite
a national resemblance, and these composers created worlds each unique
and complete in itself. Rousseau's 'I may not be better but I am at least
different' was the guiding principle of each of the Romantic composers,
and of Chopin (1810–49) above all. Some critics maintain that Chopin,
in his discovery of the evocative nature of the piano, produced a sense
of poetry and illusion in music reaching depths of sensibility unknown
to Berlioz and Beethoven. This was certainly the opinion of Debussy.
Curiously Baudelaire, the greatest critic of the poetic spirit in music
in the nineteenth century, did not respond to Chopin in the manner
that he responded to Weber or the early works of Wagner, or at any
rate he appeared not to respond to him. But an affinity was certainly
there, and we have to wait for the *Journal* of André Gide to see how the
Baudelairean spirit was in fact anticipated in the wonderful chromatic
harmonies that Chopin extracted from the recalcitrant keyboard.

There was another, related development of musical Romanticism.
The man and his music are for the first time seen to be one. This is a
principle more readily recognized in literary than in musical criticism.
Music, by its nature, is held to be too nebulous to allow a practical
and imaginative correlation of this kind. Nevertheless we are bound to
see the man and his music interrelated in this way. The glory of Georges
Bizet (1838–75), his one great triumph, is *Carmen*, probably the most
widely performed of nineteenth-century operas. He wrote it at the
age of thirty-seven. It was as if the whole of Bizet's short and often
tragic life was designed to produce this great masterpiece and that,
having given of his best in it, there was nothing more to live for.

Artists who are alive and sensitive to everything around them are
often precocious, and at seventeen Bizet had written a Symphony in

C major, a work which is as arresting and as original as any of the music written at this age by Mozart or Mendelssohn. His student years at the Paris Conservatoire belong to the pleasure-loving era of the Second Empire. This was an era of brilliance and gaiety, coinciding with the reign of the light, witty music of Offenbach. Bizet grew up in this world – and grew away from it. Winning the 'Prix de Rome', he spent three years from 1857 at the Villa Medici, the great Renaissance palace in Rome overlooking the Piazza di Spagna. He worked hard but also took part in the pageantry of Italian life. Writing to his mother of the Roman carnival, he gives a description of himself, heavily moustached, dressed up in the prettiest of baby's clothes and showering flowers on the prettiest of Roman girls. An attachment to his mother was to dominate his life for many years. In Venice, overcome with grief on hearing of her illness, he picked a quarrel with a gondolier with the one idea of strangling him. He hurried back to Paris to be annihilated by the news of his mother's death.

Bizet was now twenty-two and had set to work on his opera *Les Pêcheurs de perles*. The scene, set in Ceylon, appealed to Bizet's instinct for exotic subjects, an instinct that was to lead him to portray scenes not only in the Orient but in Scotland and in Spain, countries which he never visited but which, for this very reason, existed all the more vividly in his imagination. He went no farther south, in fact, than Bordeaux. Asked at the time of *Carmen* whether he would like to visit Spain, he replied emphatically, 'No, it would disturb me'. *Les Pêcheurs de perles* is an immature work but it displays for the first time traces of Bizet's true manner – lyrical, lithe and voluptuous.

After the success of this early opera Bizet developed in another direction. In his early youth Mozart had been his idol. Now it was to be Verdi. And he was unable to resist the spectacular appeal of another nineteenth-century opera composer, Meyerbeer. *Ivan le terrible* was his next important work, a grand opera in five acts in the style of Meyerbeer, with a big coronation scene. It was left incomplete and performed for the first time only after the Second World War.

Following these operas on oriental and Russian subjects, Bizet became attracted to a work of Sir Walter Scott, *The Fair Maid of Perth*. His opera on this subject is better known under its French title, *La Jolie Fille de Perth*. His attraction to this and other such subjects does not mean that the style of his music had taken on the characteristics of exotic countries. While writing his Scottish opera he confessed that it was Italian music to which he was particularly drawn. 'My senses',

he wrote, 'are enthralled by Italian music – facile, idle, amorous, lascivious and passionate all at once'. This opera was only mildly successful and Bizet was becoming worried by the fear of failure. Soon, in 1867, he declared that an 'extraordinary change' was taking place. 'I am changing my skin as artist and as man; I am purifying myself. I am becoming better: I feel it!' A deep-rooted change did take place. In an unfinished opera of this time, *La Coupe du Roi de Thule*, are signs of the tragic power of *L'Arlésienne* and *Carmen*. In 1869 Bizet married Geneviève Halévy, daughter of his former teacher. In a letter written shortly afterwards he describes a curious dream:

> We were all at Naples, in a delightful villa living under a purely artistic government. The Senate consisted of Beethoven, Michelangelo, Shakespeare, Giorgione, etc. . . . The vote was withheld from fools, knaves, intriguers and ignoramuses. . . . Geneviève was rather too well disposed toward Goethe, but even so waking was very bitter.

Bizet was one of the first musicians to conceive a 'brotherhood' of artists, in the manner of the Pre-Raphaelite brotherhood, a conception endorsed also by Van Gogh and by Debussy.

The Franco-Prussian War broke out in 1870 and this ideal was cruelly shattered. When the Prussian troops marched down the Champs-Élysées a new era opened. The Second Empire and the reign of Offenbach had come to an end. Frivolity and pleasure-seeking were replaced by austerity, a fervent patriotism and a new sense of national unity in face of disaster. Bizet was greatly affected by the new spirit that was breaking through. In 1871 he wrote the opera *Djamileh*, a much more characteristic work than anything he had yet written, and the following year the incidental music to Daudet's Provençal play *L'Arlésienne* with its stark contrasts of tenderness, tragedy and violence. The harassed, sensitive composer was at last becoming himself. The delightful piano suite *Jeux d'enfants*, though naïve and charming, reveals his remarkable powers of observation and description.

In 1874 Bizet was commissioned by the Opéra-Comique to write *Carmen*. Though based on Prosper Mérimée's tale of jealousy and murder, the libretto presented a rather conventional version of the violent, romantic characters. Mérimée's Carmen was an unwashed gypsy, his Don José was a depraved brigand, and Carmen's husband, Garcia le Borgne, who does not even appear in the opera, was the worst villain of them all. The conventional libretto proved, however, to be hardly

conventional enough for the nineteenth-century public of the Opéra-Comique. The nature of the subject aroused the public's suspicion. Anxious at all times for encouragement and success, Bizet was in no mood to foresee the hostility that *Carmen* was bound to provoke. He had awaited the reception of his final work 'more anxiously' we are told, 'more trembling than a criminal'. The four acts of this work of genius were over and as the curtain fell on Don José's confession of his desperate murder of Carmen there was icy silence. The composer was cruelly humiliated and he was never to recover from this bitter disappointment. Shortly afterwards, as the curtain at the Opéra-Comique fell on the thirty-first performance of his masterpiece, Bizet died. The tragedy of the death of Carmen was apparently equalled only by his own personal tragedy.

Throughout Europe *Carmen* was soon to embody the ideal of sensuality and dramatic passion in opera. 'Il faut méditerraniser la musique,' Nietzsche declared in admiration of this Franco-Spanish masterpiece. Its lithe sensuality was 'African'. We know now that Nietzsche had been reading Daudet who, in describing the scenery of the Côte d'Azur (illustrated for us today in the pictures of Matisse and Dufy), similarly uses these stark, colourful terms. *Carmen*, the Mediterranean, Matisse and Dufy – these are the associations set up in our minds today by the glinting timbres of Bizet's score. Some years later the works of the early impressionist painters are suggested by the music of Emmanuel Chabrier (1841–94), known to us not only by the subtle colours of his orchestration but by his delightful correspondence.

What is nowadays conveyed by the high spirits of Chabrier's *España*, the *Marche joyeuse* and the *Valses romantiques* is of course very much a period charm. So it is too with the composer's correspondence, which is an exact counterpart of these works. Here, in Chabrier's witty chatter, or in his amusing records of the ramblings of a Frenchman in Spain, are caught, as in a vignette, the most affecting delights of the Second Empire. He writes of the period known as *le temps des cheveux et des chevaux*, and he is therefore abundant in a supply of racy anecdotes. We see the jovial native of Auvergne off with his numerous country relatives in a carriage and pair to a village wedding, his astute ear missing nothing of the local gossip, pouncing on the village organ to improvise a parody of a wedding march, eating himself sick at the evening banquet and dancing till daybreak with the prettiest of the country wenches. In Spain, parading through the streets of Seville in the costume of a toreador, he finds the Spanish women irresistible.

Chabrier's comic vein, in the wide variety of scenes he so pointedly depicts, may be chiefly esteemed for its period value; but I am not so sure that we do not find an extension of this same comic vein in certain figures of the present day: Chabrier's biting humour is echoed, surely, in the music of Francis Poulenc, and in many of the works of Erik Satie.

The composer of the farmyard songs, *Les Cigales*, *Les Gros Dindons* and the *Villanelle des petits cochons roses* was also a collector of paintings which have since become renowned museum pieces. Among the thirty-eight pictures of his collection sold after his death were ten Manets, including the *Bar aux Folies-Bergère* (for which he paid 5,830 francs), now in the Courtauld Collection, five pictures of Renoir, who also painted his portrait, and others of Cézanne, Monet and Sisley. These literary and pictorial associations of Chabrier were, however, never fertilized in his music in the way that similar literary and pictorial associations were fertilized in the music of Debussy. It was Chabrier and not Debussy who was the personal friend of the impressionist painters, and it would have been all the more fascinating, therefore, to have Chabrier's opinion of the young impressionist composer whose early works he must surely have known. Unfortunately, Debussy is seldom mentioned in Chabrier's correspondence.

If it was not the young Debussy, who then was the God of this musical wit? It was Wagner, the 'Man of Bronze', before whom he is in abject admiration. 'Ten years', he exclaimed, literally sobbing at a Bayreuth performance of *Tristan*. 'Ten years I've been waiting for that A on the cellos!'

Nationalist Ideals

There is evidence that the scores of Wagner corresponded very closely in the mind of Chabrier to the flecked treatment of colour in the works of the impressionist painters; and indeed the Wagnerian influence was absorbed or transformed by French musicians up to the outbreak of the First World War. Massenet, a slender, somewhat sentimental figure of this period, was known as 'Mademoiselle Wagner'. After the Franco-Prussian War, an organization with national aspirations was founded, the Société Nationale with the motto 'Ars Gallica', designed to encourage native composers. The principal promoters of this society were Saint-Saëns, César Franck, Édouard Lalo and Gabriel Fauré. It was at the concerts of the Société Nationale that Franck's

principal chamber works were first given, the violin sonata, the quintet and the quartet, and also the first performances of the two most original works in French chamber music, the string quartets of Debussy and Ravel.

The Société Nationale came into existence in response to the demands of an independent spirit that was breaking through. It is interesting to observe, however, that the very musicians who were responsible for the creation of the society were soon to become aware of its limitations. A distinctive school of French chamber music had at last emerged, but limited as it was by the framework of the Société Nationale, it was in danger of becoming ingrown. Foreign works, including the quartet of Strauss and chamber works by Russian composers, were accordingly given in their programmes, and in 1909 Gabriel Fauré became the president of a rival society, the Société Musicale Indépendante, with prominent foreign composers, including Stravinsky and Bartók, on the committee. New French works were of course given at the Société Musicale Indépendante, notably the string quartets by Darius Milhaud, but they had no priority. Thus the wheel had turned full circle. The two societies continued to coexist until after the Second World War, demonstrating in the sphere of chamber music an exemplary spirit of freedom and artistic interchange.

An extremely fluent and versatile composer was Camille Saint-Saëns (1835–1921) who was easily able to adapt himself to the demands of any of the symphonic or chamber-music forms. His opera *Samson et Dalila* was a triumph. Saint-Saëns was blessed with an ease of writing (which some consider to have been his undoing), a stylish manner, seldom original, but always skilled and accomplished, so that almost everything he wrote leaves the impression of music neatly turned out and a joy, therefore, to listen to for its faultless workmanship. When this fluency of manner is allied to genuine inspiration he can still provide those delights of charm and elegance associated with this period. He was never a deep, nor even a warm-hearted composer: his personality was remote and frigid. Consequently people are surprised today to learn that Mozart was his ideal – Mozart who was also the ideal of several other seemingly un-Mozartian composers, among them Gounod, Tchaikovsky and Richard Strauss. All these composers – and this is particularly true of Saint-Saëns – absorbed and reconstructed the spirit of Mozart in their own way; which is what, at a later age, Stravinsky similarly attempted in *The Rake's Progress*. Hence the association of Mozart and Saint-Saëns, shocking as it may seem to the

purists, was a natural and also a fruitful artistic phenomenon which was to have far-reaching results. Throughout his life Saint-Saëns greatly feared the innovations of Debussy whom he outlived and whom he never ceased to denigrate in a caustic and sardonic manner. This has rebounded on Saint-Saëns – unfortunately, for his achievement has thus been unjustly belittled. His detractors amusingly maintain that what he provided was *de la mauvaise musique bien écrite*. On the other hand, he had an important influence on both Fauré and Ravel, particularly on their chamber works. They developed some kind of poetry out of Saint-Saëns's prosaic style.

The real impetus to French music after the Franco-Prussian war came not from Saint-Saëns but from César Franck (1822–90). In his book on Franck Léon Vallas emphasizes the composer's strong Germanic origin and associations. 'A Liégois by birth, a Netherlander, later a Belgian, later still a Frenchman by naturalization, Walloon by upbringing, French at heart, Franck came none the less from Germany,' declares this author, the point being that his ancestry, as it has now been disclosed, was predominantly German on his father's side and, on his mother's side, purely German. Nowadays when national characteristics of style in composition are hardly discernible, we are not greatly affected by such racial considerations, but in the nineteenth century which held to the doctrine of 'le style c'est l'homme même', the national or racial origin of a composer did very largely determine the stylistic features of his music. Meyerbeer and Offenbach were naturalized French composers who had identified themselves with the native traditions. Theirs was the genius of assimilation: these foreign-born composers respectively became the creators in France of the Romantic grand opera and the operetta. Franck, on the other hand, was a naturalized Frenchman who was able to impose on his adopted country the Romantic ideals of a musical civilization which demonstrably has its roots not in any of the masters of Latin culture but in Beethoven, Schumann and Liszt. When all the origins of Franck's individual style have been traced and identified we are faced with the fact that the sum of all these elements still does not make the whole. By any standard Franck was a powerful and original personality. He created not only a new style; he created a new world. He was an ecstatic composer who pitched music up to an almost constant state of modulation. At the same time he galvanized the structure of his works by the reintroduction of a theme from one movement into the other movements. Form and harmony are masterly in his music; and though the

sensuous and impassioned sentiment he expresses has no great variety, the impact of his music on any kind of emotional person is irresistible. Moreover, in his later works the quality of his inspiration is high. The mystical and religious associations of his art may sometimes be debatable but in the best of his music, notably the Symphony, the *Variations symphoniques*, and the piano and violin sonata, his inspiration never flags. It is in these works that one sees his wonderful use of chromatic harmony. It is music that is both flexible and taut, as if he were constantly measuring the degree of tension. By this means he takes his great spans of music to the borderline of sentimentality, but unlike some of his followers he does not cross this borderline. He was one of the most sincere of composers who believed that the spirit of music was not in the notes written down on the manuscript paper, but in the fluid nature of harmony.

The creative spirit is unpredictable. It may declare itself anywhere and at any time, in Mozart as a child, in Verdi as an old man, or – and this is the most tragic experience an artist can know – it can be given and then withheld. Faith then, too, is extinguished and ultimately even hope. Such was the tragedy of Henri Duparc (1848–1933) who, in his youth, had written some of the most beautiful songs in the whole history of music – songs that established a new form in its own right – to be haunted thereafter by fears and doubts of such intensity as to paralyse all creative activity.

In his youth Duparc developed an interest in Russian literature, then comparatively little known in France, and in the plays of Ibsen. In 1869 he travelled to Weimar, where he met Liszt and Wagner. At about this time he formed a friendship with the poets Albert Samain and Leconte de Lisle, while among the older poets he was especially attracted to Alfred de Vigny and Lamartine. He was one of several French composers of this period for whom the world of literature was almost as important as the world of music.

At the age of twenty Duparc published five songs, including the famous *Soupir* and *Chanson triste*. The series of fifteen songs, fourteen of them with orchestral accompaniment, on which the composer's reputation stands today, had been begun. They were written over a period of sixteen years. At the age of twenty-one, he wrote *Au pays où se fait la guerre* and in the following year *L'Invitation au voyage*. Then came *La Vague et la cloche*, the only one of the set originally conceived with piano accompaniment, the *Élégie* and *Extase*, deliberately written in the style of *Tristan* in order to snub the critics reproaching him with

writing in the style of Wagner. The remaining songs follow almost at annual intervals.

Duparc was constantly threatened by some sort of overpowering inhibition. 'It is frightful to be so neurotic as I certainly am,' he declared to a friend in 1888; 'the least little thing completely finishes me.' He appears to have enjoyed a certain degree of facility up to the age of forty; thereafter a few bars a day was all he could manage to set down on paper – and the following day even these preliminary sketches were likely to be scrapped.

The career of Paul Dukas is one of the least spectacular among those of the composers of his period. His evolution was slow, his works were few. By nature he was retiring, and of that philosophical turn of mind intent less upon action than upon pondering an aesthetic problem in its infinity of aspects; thus, inevitably, he approached creation with diffidence. Moreover, Dukas was a critic and a remarkable teacher as well as composer, and many of his finest efforts were devoted to the encouragement of his talented pupils, among them the twentieth-century French composers Elsa Barraine and Olivier Messiaen.

Dukas is known to us today by a single work of his youth, *L'Apprenti sorcier*. It is always a moving experience to see the admiration and respect of the more discerning minds among the musical public for an artist who has not quite fulfilled his mission. Perhaps it is the knowledge that the values of success, or for that matter of failure, can never be finite; that fulfilment for the creative artist on the rare occasions when it is nearly complete – it can never be entirely complete – must leave a fearful void, hardly less agonizing than the frustration of the imaginative though unproductive artist; perhaps it is the purely human aspects of a composer's work that will all the more endear his achievement to his fellow musicians. One is grateful that a composer of music is after all human. And should his entire achievement turn out in the end to be relatively small and incomplete, how high-minded is such a musician to renounce success for the untiring pursuit of an ideal, even though it remains undefined at the time of his death.

In his homage to the composer, Paul Valéry recognized the nobility and integrity of a rare philosophical spirit in music, who owed as much to Descartes and Schopenhauer as to Rameau, Beethoven and Wagner. The virtuosity of Dukas, he observed, 'n'était point le fruit d'une quantité d'exercices tant que la récompense d'une méditation perpétuelle des moyens de la musique avec son objet.'

This French musical Renaissance – for it was nothing less – produced

an endearing figure in Gabriel Fauré (1845-1924). In a sense the whole of the music of Fauré, including the choral works and the piano works, and particularly the songs, is essentially music noted down for personal or private communication. When Fauré's engagement was broken off to Marianne Viardot, daughter of the famous operatic singer Pauline Viardot, he consoled himself by declaring that the proposed marriage would only have orientated his work towards the stage and the opera, for which he felt himself singularly unfitted, and that he was now free to follow his life's ideal which, as he put it, was his *musique de chambre*. Fauré's art has not only the quiet intimacy of a conversation between musicians; it is deliberately conceived as a sort of monochrome, hushed and suave, and excluding in its civilized manner any hint of rhetoric or romantic violence of expression.

In England Fauré made a great appeal in the period between the wars. English musicians at that time felt an affinity with the essentially sober qualities of Fauré's music. Certain works of Vaughan Williams and also of Berkeley and Britten show, not an influence of Fauré, but, as we now see, similar standards of modesty, sensitiveness and under-statement. Somehow the musical civilizations of England and France seem to find a bridge in the work of Fauré.

Fauré's music was not adventurous in any technical sense, but in his chamber-music conception of what music was to be there were many new subtleties of expression. Drama or conflict is unknown to this urbane musician, but he can charm by the elegance of his discourse, by his long, beautifully sustained melodies spun out with a love of delicate detail and often with a provocative twist of phrase that un-expectedly opens up a new vista or a new layer of musical thought. Although he lived through the eras of the revolutionary works of Debussy and Stravinsky, Fauré's harmony remained predominantly diatonic, and for this reason he was long considered to have been a conservative. The fact is that he was a great traditionalist. It is true that his unobtrusive art was overshadowed by the innovations of the many forward-looking minds among his contemporaries. And it is also true that more than any other composer his master, Saint-Saëns, remained his model. But the pupil was far from a slavish imitator. He endowed the prosaic style of Saint-Saëns with a sense of poetry; the frigid man-ner of his conservative master is made to glow with human warmth.

Fauré's melodies are not always remarkable in themselves, but as they settle in the mind they usually become so just by the composer's subtle ability to make of the commonplace something fresh, original

and personal. This happens in several ways, but chiefly by means of Fauré's very beautiful modulations. Like Franck, Fauré earned his living as a professional organist, and it was no doubt his long experience in improvisation at the organ that developed his individual approach to modulation. Now the art of modulation in eighteenth- and nineteenth-century music, particularly in Mozart, Chopin and Schubert, is a highly personal aspect of the composer's technique, touching upon the whole mysterious mechanism of his harmonic language. But here the musical personality of Fauré is completely opposed to that of his contemporary, Franck, who prized modulation for its own sake, as if harmony was simply not to be maintained in any kind of static state, but was constantly to be intensified or distorted by chromatic inflections. Fauré's harmony is never chromatic in this sense; the planes of his music are broader, so to speak, and consequently when he does modulate (which is usually by the use not of adjacent notes, but of notes common to the two tonalities) the effect is less nervous and taut. He does not travel in his music in a state of agitation or confusion; his mind is organized and at peace and the vistas which his modulations disclose fall into perspective like the various planes in a picture. Here is a satisfying art to look back on after the strains put upon music during the first half of the twentieth century – an art of conventional associations maybe, but quiet, civilized and reassuring.

Twentieth-Century Masters

I think it must have been Arnold Bennett who first put into the minds of musical people in England that Ravel (1875–1937) was a composer of the stature of Debussy, and that henceforth – he was speaking of the period before the First World War – these two composers, Debussy and Ravel, were to be the twin masters of twentieth-century French music. Bennett had earlier believed that Debussy was unique among the French composers of his time. Now he was no longer so, he declared. Another twentieth-century composer was showing how music could serve not an ideal of abstract argument, not an architectural or dramatic ideal, but the sensuous ideal, an ideal based in fact on the supremacy of a guiding principle in French civilization, 'the pleasure principle'. There was a lot in this of course and certain works of Ravel did at one time seriously threaten Debussy's supremacy in this hedonistic sphere. Later generations took a different view. Ravel is no longer

coupled with Debussy as if they were the Haydn and Mozart of their time. Indeed, critics tend nowadays to diminish the figure of Ravel, maintaining that he was after all only a minor figure, a commendable craftsman whose turn of mind was nevertheless unadventurous and whose scope of expression was limited to the picturesque. He was a miniaturist.

I think the time has come, if not for a broad reassessment of this now underrated composer, at any rate for a survey of the problems with which the biographer of Ravel and the student of his music is likely to be faced in the future. There is no doubt that the production in 1902 of Ravel's *Jeux d'eau* and, a few years later, of his song cycle *Histoires naturelles*, proclaimed a composer of genius. They were immediately acclaimed in those days as works on this superior level, and indeed their originality is acknowledged still. *Jeux d'eau*, which marks a distinct advance on Liszt's *Jeux d'eau à la Ville d'Este*, is not only the most important of Ravel's water pieces; his understanding of the character of the piano and all that it could be made to yield in the matter of illusion and suggestion opened a way to an entirely new piano technique later developed by Debussy in the *Estampes*. On the matter of musical symbols representing the movement of water – a motif near the hearts of the impressionist painters – Ravel's *Jeux d'eau* precedes not only Debussy's *Jardins sous la pluie*; it precedes *La Mer*. As for the success of the *Histoires naturelles*, this can be measured by the fact that as a musician of nature and a caricaturist Ravel was considered to have surpassed Mussorgsky. From the amusing manner in which the habits of the peacock are portrayed in this cycle one can see how this impression was created. Elsewhere when we consider the marvellous tapestry of sounds in the second part of *L'Enfant et les sortilèges* composed in imitation of the croakings of tree-frogs, the trills of nightingales and the shrill hoots of bats, then some sort of primitive spirit seems to have entered into music and the rhetorical portrayal of nature, as practised by the Romantic musicians, appears by contrast to be quaintly old-fashioned. Neither Beethoven's Pastoral Symphony nor Wagner's 'Forest Murmurs' has the magic of Ravel's nature scenes. If it is true that progress in art means progress in the direction of realism – the use of symbols which more and more resemble the real thing – then the forest scene from *L'Enfant et les sortilèges* is among the greatest nature scenes ever conceived by a composer of music.

Though Ravel lived to the age of sixty-two the list of his works is short. Also, the length of his works, in days when the symphonies of

Mahler, Bruckner and Shostakovitch are acclaimed, is not exactly excessive. 'Fifty-six minutes,' announced Franc-Nohain with stop-watch in hand at the conclusion of Ravel's longest work, the opera *L'Heure espagnole*. But brevity cannot be a reason for the deprecation of Ravel: the rare choice product is a French phenomenon. Could it be impatience with his over-refinement? I hardly think so. The French have often been cruel to the children of their revolutions – Berlioz for instance – heartlessly ignoring these fiery figures when others were ready to embrace their cause; but that is not quite the problem with which we are concerned here, since Ravel was not exactly a revolutionary composer and in any case one has never been surfeited with his varied works. I think a more likely explanation lies in the fact that the music of Ravel does not evolve. His character was declared in the early song 'Sainte' and although the inner tension of his music increases, at times almost to breaking-point, his work does not radically develop, it does not become the music of a greater composer. All the same, at the end of his life Ravel's work did fork out in two directions: to the empty repetitiveness of *Boléro*, which quickly crossed over into the realm of popular music, and to the powerful inspiration of the Piano Concerto for the Left Hand in which Ravel came nearest to bursting the vein of his genius. The contrast between these two works is alarming, and indeed they were shortly to be followed by his mental collapse. Tension had been brought to breaking-point, and beyond.

At the time of the death of Claude Debussy (1862–1918) at the end of the First World War, and even during his lifetime, it was felt that here was a figure who had radically changed the whole course of music. We still feel this, but perhaps it is only about now that we may begin to see what it was that Debussy changed, and to measure the extent of his influence. This is not surprising. Debussy explored a vast new musical world; he struck deep at our whole conception of music, and in a way from which there was no going back. But precisely because his work is still too near us it has not been so easy to reconstruct the original experience of Debussy's art or to assess his influence.

In any assessment of Debussy as he appeared to his contemporaries we must be concerned first of all with a type of sensibility common to the writers and painters of his period. It is right to say that the art of Debussy is not merely a reflection of one aspect or another of his period: it is the period itself. The landmarks in the history of the symbolist movement were the *Romances sans paroles* of Verlaine, Mallarmé's poem *L'Après-midi d'un faune* and Maeterlinck's play *Pelléas*

et Mélisande. These were precisely the works at the root of Debussy's inspiration. Moreover, in the great literary movement that spread from Baudelaire to Proust, characterized by a feverish response of the senses, music was regarded as the quintessential art, and there was no other composer who so closely realized the musical ideals to which the writers of this period openly aspired. In painting, the main elements of impressionism originated from the English Pre-Raphaelites, the art-nouveau and the work of Turner. Here again the work of Debussy, who declared that he was drawn to painting almost as much as to music, has important visual associations.

For these reasons we cannot approach the art of Debussy as a purely musical phenomenon. It belongs as much to the history of literature and the visual arts as, specifically, to the history of music, and it plays a part, too, in contemporary psychological thought. Concepts of the dream preoccupied Debussy in the 1890s, as they preoccupied André Gide (in *Le Voyage d'Urien*), Mallarmé and, in an allied sphere, Freud whose first works, *The Interpretation of Dreams* and *Studies in Hysteria*, appeared during the very time of the composition of *Pelléas et Mélisande.*

It is interesting to see that the figure of Roderick Usher in Poe's tale, *The Fall of the House of Usher*, to which Debussy was so strongly drawn, was the prototype of the new artist embracing music, painting and poetry. Roderick Usher was a poet whose verse, in the words of Poe, 'had an undercurrent of meaning'; he was a painter whose 'pure abstractions on the canvas grew touch by touch into vagueness'; and he was a musician, for we read that 'his wild improvisations on the guitar were the result of a morbid condition of the auditory nerve which rendered all music intolerable to the sufferer, with the exception of certain effects of stringed instruments'. Readers of French literature will immediately see reflections of Roderick Usher, the Hamlet-like character almost incapable of decision but with sudden explosions of violence, in Huysmans's Jean des Esseintes, in Oscar Wilde's Dorian Gray, in Robert de Montesquiou, the friend of Proust, possibly in Proust himself, certainly in Maeterlinck's Pelléas, and in the ambivalent character of Verlaine. Wholly in keeping with this outlook, Debussy declared that Poe exercised 'an agonizing tyranny' over him.

We have also to correlate Debussy's aesthetics with his personal character. In simple terms we want to know what the composer was like and how it came about that this music was written by this man. This is obviously the main purpose of musical biography, but although

there have been a number of lives of Debussy his personality has largely eluded us. In introducing the exhibition 'The Sources of Twentieth-Century Art' recently held in Paris, Jean Cassou made the point that underlying the work of the artists of Debussy's period, notably Gauguin and Van Gogh, there was always 'a personal tragedy'. There was a similar tragedy in the life of Debussy, not so readily discernible but fundamentally of the same nature as that which drove Gauguin and Van Gogh to their terrifying excesses. Typical of the period was the more open manifestation of homosexuality, apparently allied to a refined sensibility, and entailing the unfortunate dramas in the lives of Verlaine, Tchaikovsky and Oscar Wilde.

Until recently little was disclosed of Debussy's inner life. It has been shrouded in mystery or obscured by ill-founded legends. Biographical research has now shown that at critical periods in his development Debussy was in one way or another associated with the upheavals in the lives not only of Verlaine and Tchaikovsky but also of Wilde. The son of a ne'er-do-well father, imprisoned during the Commune, he found himself thrust as a child into the conflict between Verlaine and Rimbaud. He first studied music with Verlaine's mother-in-law, Madame Mauté, at the very time when this benevolent woman was fully preoccupied with the triangular situation that had arisen between Rimbaud, Verlaine and her daughter Mathilde. Later he was aware, as a protégé of Nadezhda von Meck, of the extraordinary relationship between this Russian millionairess and Tchaikovsky; and his friendship with Pierre Louÿs could not have left him indifferent to the plight of Oscar Wilde whom he knew personally and whose artistic ideals he shared. This hinterland illuminates not only some of the more obscure aspects of Debussy's life, his abject poverty, his appalling debts, and the circumstances which compelled him to drive to suicide both his mistress and his first wife; it reveals the soil in which his acute sensibility, compounded of pleasure and violence, was nurtured.

His conception of pleasure, the pleasure of the senses, was courageous. 'I don't know whether you are like myself, a maniac for happiness,' he wrote to a friend. What can this signify? I think we may discover its meaning in the words of another writer. 'Happiness is not in the intellect or the fancy', wrote Melville, 'but in the wife, the heart, the bed, the table, the saddle, the fireside, the country': earthly pleasures, in other words. If we cannot believe that the Faustian ideal of Eternal Womanhood is real, what then is real? Debussy admired in Faust not the conception of Eternal Womanhood but the character of the watchman

Lyncaeus, who was overpowered by a vision of beauty. Sensations, then, are real, and so are the pursuit and renewal of sensations. It is a dangerous but a beautiful conception, and as the sham of earlier philosophies was exposed it was the only conception. Not for nothing was it said of *L'Après-midi d'un faune* by the critic, Willy, master of witty epigrams, 'Faune y soit qui mal y pense'.

No study of Debussy can ignore the conflict with Wagner, the huge wrestle that was nothing less than a life-and-death struggle for musical survival. The view generally put forward is that there was a period of transitory Wagnerism in Debussy's youth, seen in the *Poèmes de Baudelaire* and *La Damoiselle élue*, from the time of his visits to Bayreuth, and that later, under the influence of Mussorgsky, there was a period of 'de-Wagnerization'. We can no longer accept this. There is no doubt that Debussy freely recognized Wagner as the greatest single artistic force of the nineteenth century, and although he was in the habit of making many jibes at Wagner, such as the one on Wagner's use of the leitmotive ('It is as if his characters were lunatics compelled to present their visiting cards in music each time they stepped on to the stage'), we have to remember that Debussy was a master ironist whose statements were frequently designed to conceal the depths of his true feelings. A revealing letter from Pierre Louÿs starts: 'We recently had a very serious conversation on the subject of Richard Wagner. You said things nine-tenths of which you simply don't believe. I merely stated that Wagner was the greatest man who had ever existed, and I went no further. I didn't say that he was God himself, though indeed I may have thought something of the sort.' Other recently published correspondence reveals that the Wagnerian conflict preoccupied Debussy throughout his career.

What principally emerges from all of this is that Wagner's ideal of the fusion of the arts was realized, apart from his own stupendous achievement, not in Germany but in France, and there not quite in the way he had expected. It is clear that Wagner gave an enormous impetus to the artistic cross-fertilization such as we find in Mallarmé, in Proust (the whole of *A la recherche du temps perdu* is in this sense a Wagnerian work), and principally in Debussy. The use of the leitmotive technique, so disparaged, is one of the principal features of *Pelléas et Mélisande*.

In his great study of the present state of music, *Les Fondements de la musique dans la conscience humaine*, Ernest Ansermet is inclined to think that Debussy was alone in his capacity to absorb and transform the

Wagnerian ethos. It is certain that the daringly sensuous symbolism of *Parsifal* was the most inspiring experience of his youth and it remained so until the end of his life. It fertilized his imagination not only in the early *La Damoiselle élue*, but in many later works. Listening to *Pelléas* in the company of Ravel and Romain Rolland, Richard Strauss declared, 'Why, there is the whole of *Parsifal!*' Echoes of the music of the bleeding wound of Amfortas are heard in *Le Martyre de Saint Sébastien*; and even the ballet *Jeux*, Debussy's last and perhaps his most original orchestral work, is shot through with memories of the Flower Maidens. It attempts to recapture, as Debussy stated, 'that orchestral colour that appears to be illuminated as from behind and of which there are such wonderful effects in *Parsifal.*'

At the time of the composition of *Jeux*, in 1913, Debussy was beginning to be seriously alarmed at the cult of novelty in music for its own sake, what he called the *esthétique pour magasins de nouveautés*. To his friend André Caplet he wrote a remarkable letter in the form of a shrewd analysis of contemporary trends, concluding on a note of touching humility. 'After all', he says, 'the adventure of Wagner is not likely to be made available again for just anyone.' If we look further into this statement I think we see that Debussy had in mind the development of Stravinsky: 1913 was the date of *Le Sacre du printemps*, and it was also the date of the parting of the ways between the two composers. Debussy apparently hoped that music might be kept alive by some kind of allegiance to Wagner, however hidden, whereas for Stravinsky any form of Wagnerian inspiration was anathema.

Linked with this Wagnerian inspiration was that of the Russian composers. Reams have been written on a supposed affinity between Debussy and Mussorgsky which make strange reading today. 'You are going to hear *Pelléas*?' Debussy said to a friend, 'then you will hear the whole of *Boris Godunov.*' These words have often been quoted without the realization that they are purely ironic, delivered in the same tone, in fact, as the taunting remark to André Gide: 'The whole of my work derives from the fourth Ballade of Chopin.' From this distance of time I think we may see that Mussorgsky's great reputation in France derived from a desire to discover an anti-Wagner. Mussorgsky was greatly admired by Debussy but the affinity with Tchaikovsky, notably in *L'Après-midi d'un faune* and the Scherzo from the String Quartet, is at least as significant and has been entirely neglected.

Debussy's inspiration branches out in many directions, and so does his technique. Not only are elements of Wagner and the Russians

discernible in his style. He plunged back into the Middle Ages, using the Gregorian modes; he used the pentatonic scales of the Far East; he was influenced by the masters of the French and Italian Renaissance, and also by the popular music of the day, the cake-walk and music-hall tunes. I would concede that this ever-widening panorama which Debussy embraced was not only his strength but his weakness. Inspiration drawn from so many sources can lead to eclecticism and thence to disintegration.

There is finally the question of the many projects of Debussy and of the works that were either left unfinished or that have mysteriously disappeared. These range from an early setting of a scene from Villiers de l'Isle-Adam's play *Axël* to the unfinished *La Chute de la Maison Usher* and include a setting of Rossetti's *Willow Wood*. Many composers have left projects abandoned or transformed, and frequently they illuminate phases of their development. But this is not entirely the case here. Probing in his later years into deeper poetic associations, Debussy spoke of 'le délicieux mal de l'idée de choisir entre toutes'. The final exteriorization of a work was frequently difficult for him and even, as the ideal, repugnant. 'Define aims? Finish works? These are questions of childish vanity,' says Monsieur Croche (an imaginary figure based on Valéry's Monsieur Teste and who was used as an *alter ego* in Debussy's music criticisms). One is reminded of the letters of Rainer Maria Rilke in Debussy's expressions of the spiritual poverty of the artist faced with the accomplishment of his work ('Finir une œuvre, n'est-ce pas un peu comme la mort de quelqu'un qu'on aime?'). But it was an honest view. The creation of a work of art is after all a compromise which the dreamer, the true dreamer loyal to his vision, rejects.

Mid-twentieth-century music produced Francis Poulenc and Darius Milhaud, salient figures of 'Les Six', promoted by Erik Satie (1866–1925) and Jean Cocteau. This was a group of extrovert composers whose motto might have been 'Tous les genres sont bons hormis le genre ennuyeux'. Satie, the friend of Debussy and Ravel, was the great enigmatic figure of the early twentieth century. Relatively unknown until he reached middle age, he emerged as a child among the great. His music conveyed an impression of hopelessness and impotence or, alternatively, of some kind of pert, unnaturally buoyed-up confidence. The more familiar view of Satie is of an exhibitionist and an eccentric.

Are the quirks of Satie as amusing as they seemed in his day? Hardly. Many great names have been associated with him, among them

Mussorgsky and Le Douanier Rousseau. But the ideal of a child-like innocence which they achieved was only partly realized by Satie. A small number of his works have still this innocent freshness; others are dated or forgotten. It is clear that when his spontaneous vein failed him, eccentricity was the screen he used to conceal impotence. To be sure, many of his contemporaries divined something quite unexpectedly pure in the soul of Satie – 'this sweet medieval musician' as he seemed to Debussy 'who has strayed into our century by mistake'. It is indeed tragic that this associate of Picasso, Stravinsky, Debussy and Ravel should eventually have been demolished by a crippling neurosis leaving him materially and artistically a pauper at the mercy of his successful friends.

One recalls finally that French music had often followed ideals of moderation and reason. 'L'économie des moyens' was a guiding principle, sometimes, however, trampled upon. Berlioz was inspired by notions, not of moderation, but of extravagance and of a larger-than-life ideal. Twentieth-century composers pursuing this extravagant ideal are Olivier Messiaen, the ornithologist and orientalist among French composers, and Pierre Boulez, critic and exponent of Debussy and Mallarmé, in whose all-embracing works the frontiers are crossed from music to sound, and beyond this, from sound to noise.

Bibliography

The standard works on French music of the Middle Ages and Renaissance, as indeed on all European music of those periods, are Gustave Reese's *Music in the Middle Ages* (London, 1941), and *Music in the Renaissance*, revised ed. (London, 1959). But both these books are technical and highly detailed, and the non-specialist reader might do well, for these periods, to consult one of the more general histories of music, such as the *Pelican History of Music*, edited by Alec Robertson and Denis Stevens, 3 vols (London, 1960–8); D. J. Grout's *A History of Western Music* (London, 1962); F. W. Sternfeld (ed.), *A History of Western Music*, 5 vols (London, 1973); the *New Oxford History of Music*; or Roland-Manuel (ed.), *Histoire de la musique, I: des origines à J.-S. Bach* (Paris, 1960), and *II: du XVIIIe siècle à nos jours* (Paris, 1963). Indeed, such general histories of music will also often give a welcome perspective to composers of later periods.

For the late Middle Ages (fourteenth and fifteenth centuries), an excellent view of the interrelationship of literature and music may be gained from Nigel Wilkins's *One Hundred Ballades, Rondeaux and Virelais* (Cambridge, 1969). This contains a hundred poems, some musical settings of them, and an explanatory introduction.

For the Renaissance itself, apart from Reese's book and the general histories of music mentioned above, there is an illuminating book on the French chanson and

in particular on its relationship to the Italian madrigal: James Haar (ed.), *Chanson and Madrigal 1480–1530* (Harvard, 1964).

French Baroque Music from Beaujoyeulx to Rameau is the title of a book by James R. Anthony (London, 1973), and it justifies its title. It covers in detail instrumental and vocal music, sacred and secular, in France in the baroque period.

Ballet and opera, highly important art forms in France in the sixteenth and seventeenth centuries, are the subject of three excellent books. Margaret M. McGowan's *L'Art du ballet de cour en France 1581–1643* (Paris, 1963) covers the earliest years of the ballet, from its beginnings in the Renaissance through to the first half of the seventeenth century. Behind the grandeur and ceremony of these forms lay certain political aims; and the relationship between politics and music is explored in a recent book by Robert M. Isherwood, *Music in the Service of the King* (Cornell, 1973). This relationship was of course a continuing one, but Mr Isherwood has chosen to limit himself above all to Lully and the reign of Louis XIV. Thereafter the reader may take up the story in a book of rather more traditional approach, Norman Demuth's *French Opera: its Development to the Revolution* (Sussex, 1963), which is full of facts and continues up to the end of the *ancien régime*.

Two other important books on composers of the baroque period are Cuthbert Girdlestone's *Jean-Philippe Rameau: his Life and Work* (London, 1957; paperback reprint 1969) and Wilfrid Mellers's *François Couperin and the French Classical Tradition* (London, 1950). Shlomo Hofman's *L'Œuvre de Clavecin de François Couperin le Grand* (Paris, 1961) is technical but still readable.

Turning to Berlioz: highly recommended is Hugh Macdonald's little book *Berlioz: Orchestral Music* (London, 1969), in the BBC Music Guides series. It is short, cheap and has the merit of examining above all the music itself. A.E.F. Dickinson's *The Music of Berlioz* covers much more ground but is much more expensive. For Berlioz's biography, and his place in the civilization of his time, there is Jacques Barzun's monumental *Berlioz and the Romantic Century*, 2 vols (New York, 1969), which is also available in paperback in another version called *Berlioz and his Century*.

From Bizet to the Second World War, the reader is well served with biographies. We can easily find out, if we wish, facts about composers' lives, love-affairs, artistic influences, impressions – but all too often, it must be said, we are left wanting more analysis and discussion of the music itself. The pendulum is swinging in that direction, and there is every indication that in books being written today more attention is being given to the music.

An older book, but interesting in that it specifically relates the composer to his milieu, is S. Kracauer's *Offenbach and the Paris of his Time* (London, 1937). On Bizet, there is Winton Dean's *Georges Bizet: his Life and Work* (London, 1965); and on Chabrier, Rollo Myer's *Emmanuel Chabrier and his Circle* (London, 1969). Composers of this time would indeed appear to have moved in circles. Another one is described in James Harding's *Saint-Saëns and his Circle* (London, 1965); and yet another in Laurence Davies's *César Franck and his Circle* (London, 1970). Both of these books are packed with ample information. A good general book on this period is Martin Cooper's *French Music from the Death of Berlioz to the Death of Fauré* (London, 1951), now available in paperback.

On the magical songs of Duparc, only fifteen in number, Sidney Northcote's *The Songs of Henri Duparc* (London, 1949) is i lluminating. And perhaps this is the place to mention a classic on the subject of French song from Berlioz to Poulenc: Pierre Bernac's *The Interpretation of French Song* (London, 1970). This authoritative, sensitive and detailed work is primarily for the person who actually wishes to sing the songs himself – which is of course the best way to get to know them.

As well as Edward Lockspeiser's *Debussy: his Life and Mind*, 2 vols (London, 1962–5), we are fortunate in having two short recent books, both in paperback, that look clearly, readably and in detail at Debussy's music. They are Frank Dawes's *Debussy: Piano Music* (London, 1969), in the BBC Music Guides series that I have mentioned before; and Roger Nichols's *Debussy* (London, 1973), in the Oxford Studies of Composers series. Again in the BBC Music Guides series, and again to be recommended, is Laurence Davies's *Ravel: Orchestral Music* (London, 1970): while for more biographical facts about Ravel we can turn to Rollo H. Myers's *Ravel: Life and Works* (London, 1960).

For Erik Satie, we are well served. Roger Shattuck's wide-ranging book *The Banquet Years* (London, 1959) sets him in the context of the age in which he lived; there are four chapters on four most original artists: one on Satie, one on Jarry, one on Henri Rousseau, and one on Apollinaire. Perceptive (and also available in paperback) is Pierre-Daniel Templier's *Erik Satie*, translated by E. L. and D. S. French (Cambridge, Mass., and London, 1969). And again for a more biographical approach, we may turn to *Erik Satie* by Rollo H .Myers (London, 1948; paperback reprint 1968).

Francis Poulenc: l'homme et son œuvre by Jean Roy (Paris, 1964) is a good account of the man and his work in the familiar style of the Seghers editions, that is to say with quotations from critics, tables of works, some pictures, etc. There is also H. Hell's *Francis Poulenc*, translated by Edward Lockspeiser (London, 1959).

The general development of music in this century is the subject of Jean Roy's very informative *Musique française: présences contemporaines* (Paris, 1962). It gives many facts, discussion of lives and works , and very full lists of works. More recent, though perhaps too biographical, is Rollo Myers's *Modern French Music* (Oxford, 1971), which covers the period from 1900 onwards. Perhaps this is the place to mention another general work: Laurence Davies's *The Gallic Muse* (London, 1967) which goes from Fauré to Poulenc. And a most interesting perspective on French music from Berlioz to Satie may be gained from a selection of letters of musicians, translated and edited by Edward Lockspeiser, called *The Literary Clef* (London, 1958).

A clear perspective on very modern music is difficult to get, because we are too close to it. Two books may help. One is Claude Samuel's *Entretiens avec Olivier Messiaen* (Paris, 1967), which is strictly in the form of interviews with Messiaen. The other is *Boulez on Music Today*, translated by Susan Bradshaw and Richard Rodney Bennett (London, 1971), which gives not at all a historical view of modern music, but Boulez's own ideas, sometimes very technical ones, about music and musical composition.

Brian Jeffery

INDEX

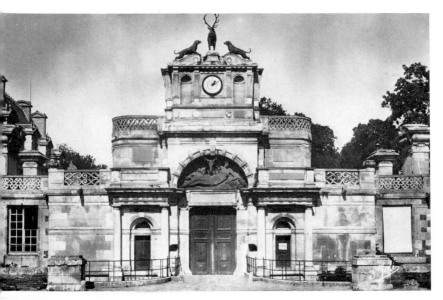

1. Anet. Château. Entrance.

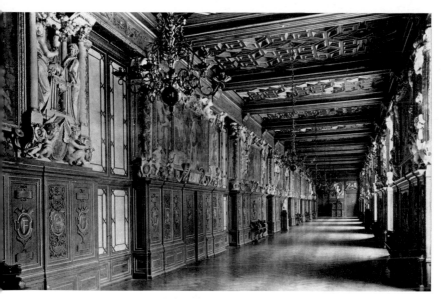

2. Fontainebleau. Galerie François I.

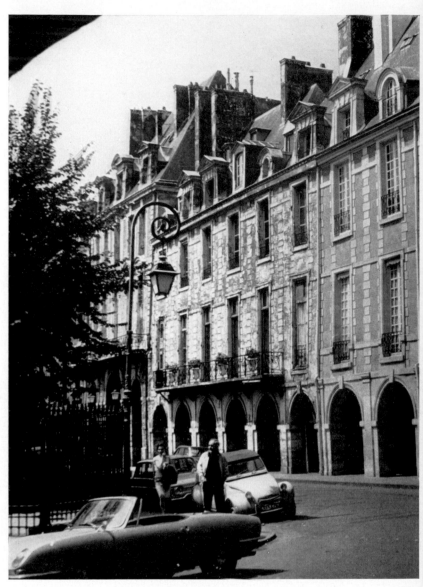

3. Paris. Place Royale (Place des Vosges).

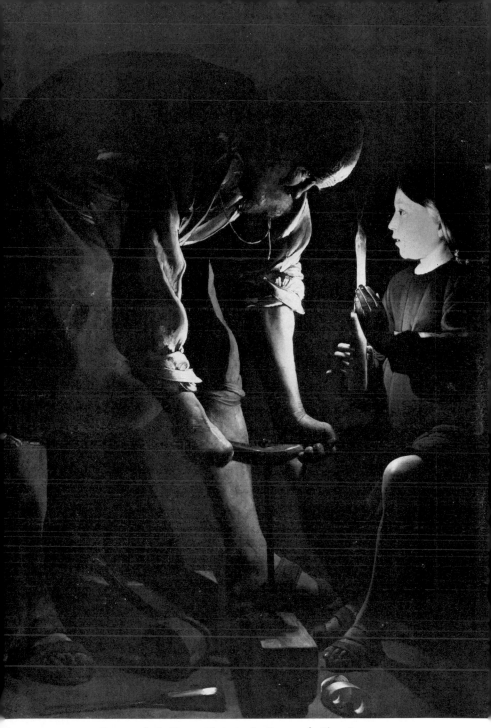

4. Georges de la Tour. *Christ in the Carpenter's Shop*. Louvre.

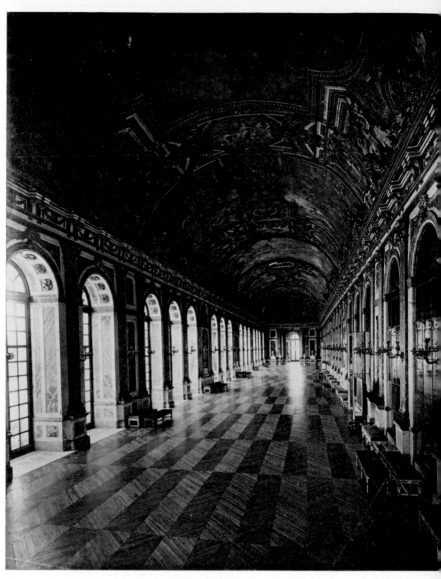

5. Versailles. Galerie des Glaces.

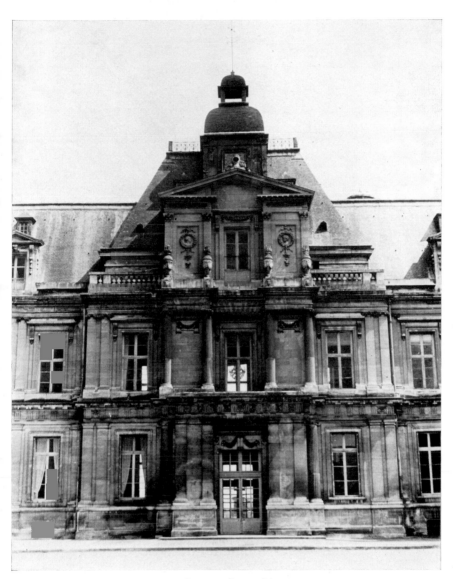

6. Maisons-Lafitte. Château.

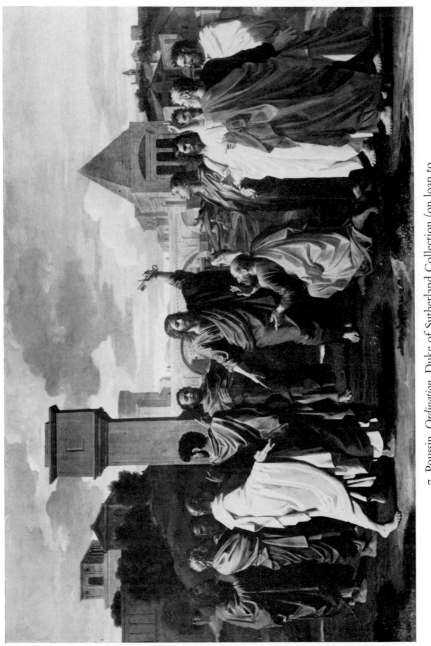

7. Poussin. *Ordination.* Duke of Sutherland Collection (on loan to National Gallery of Scotland, Edinburgh).

8. Claude Lorrain. *The Rape of Europa.* Royal Collection.

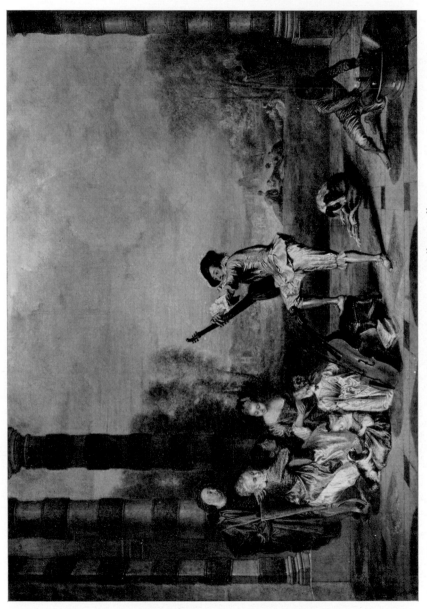

9. Antoine Watteau. *Le Concert.* Wallace Collection.

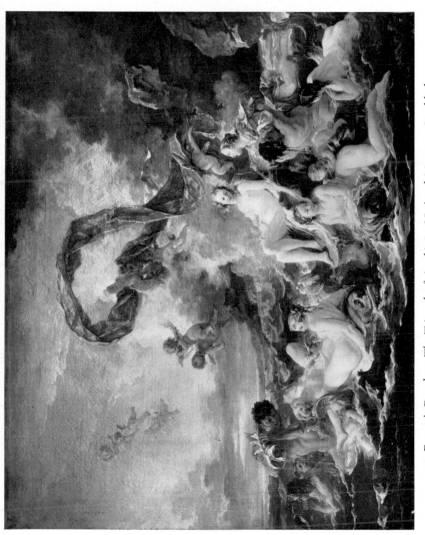

10. François Boucher. *The Triumph of Amphitrite.* National Museum, Stockholm.

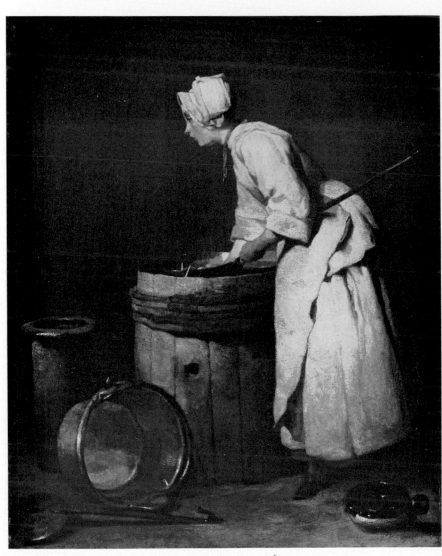

11. Jean-Baptiste-Siméon Chardin. *L'Écureuse*. Hunterian Museum, Glasgow University.

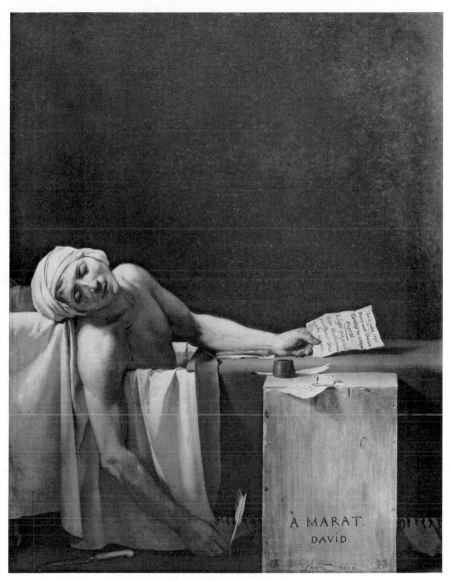

12. Jacques-Louis David. *The Death of Marat*. Musée
des Beaux-Arts, Brussels.

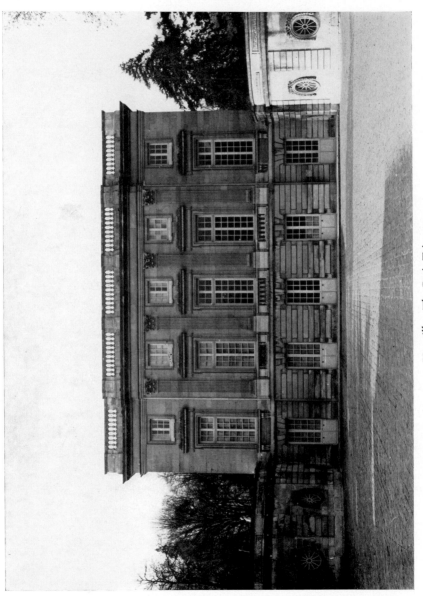

13. Versailles. The Petit Trianon.

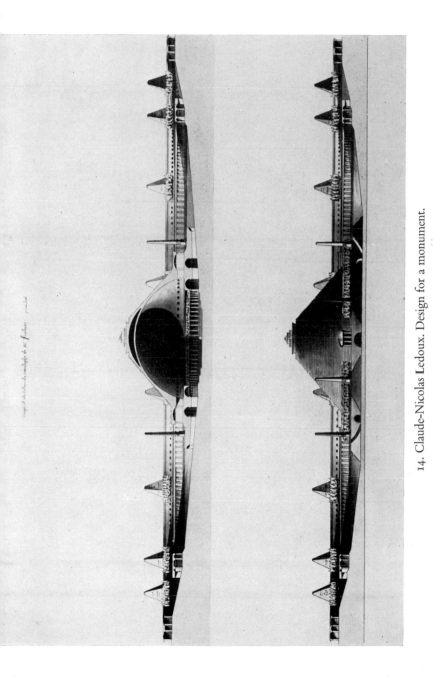

14. Claude-Nicolas Ledoux. Design for a monument.

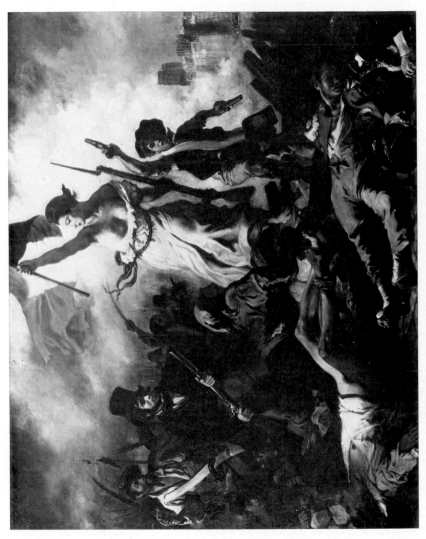

18. Eugène Delacroix. *La Liberté aux barricades.* Louvre.

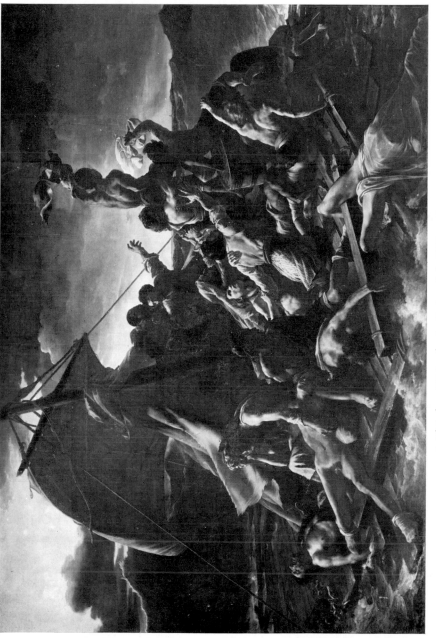

16. Théodore Géricault. *Le Radeau de la Méduse.* Louvre.

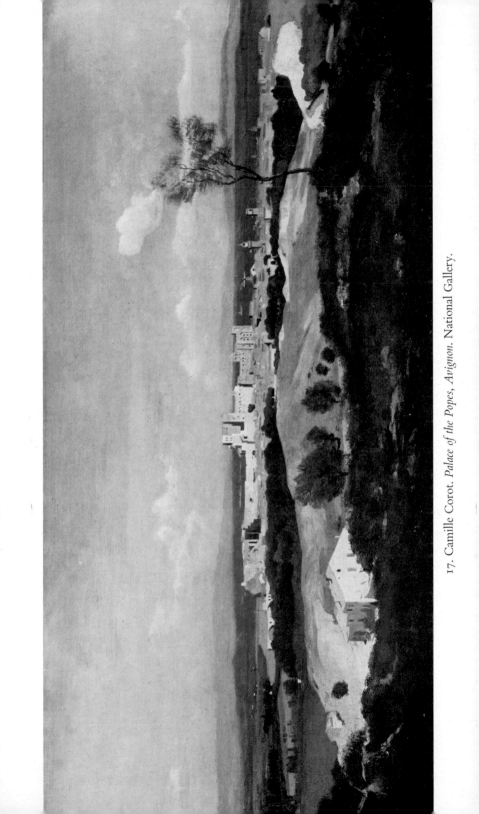

17. Camille Corot. *Palace of the Popes, Avignon*. National Gallery.

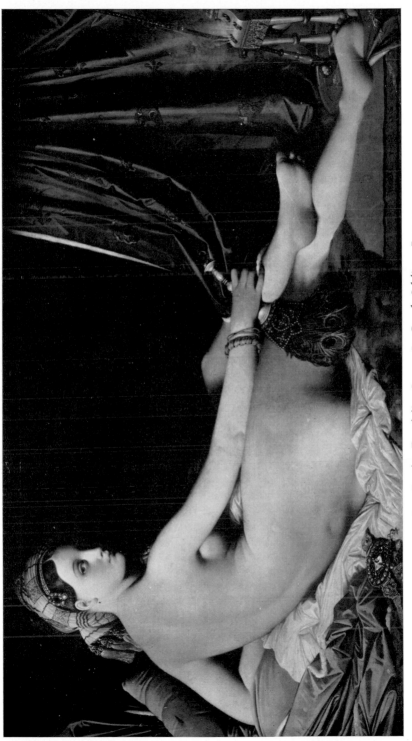

18. Jean-Baptiste-Dominique Ingres. *La Grande Odalisque.* Louvre.

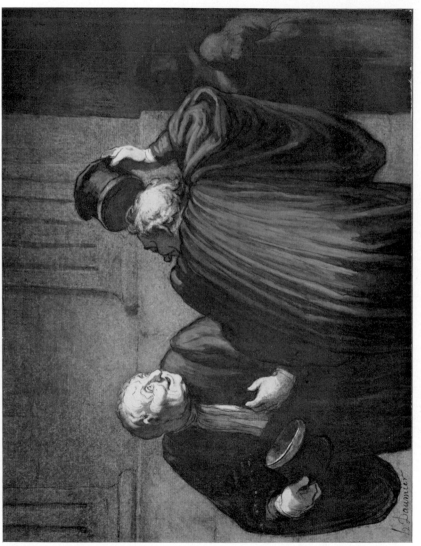

19. Honoré Daumier. *Bons Confrères*. Burrell Collection, Glasgow.

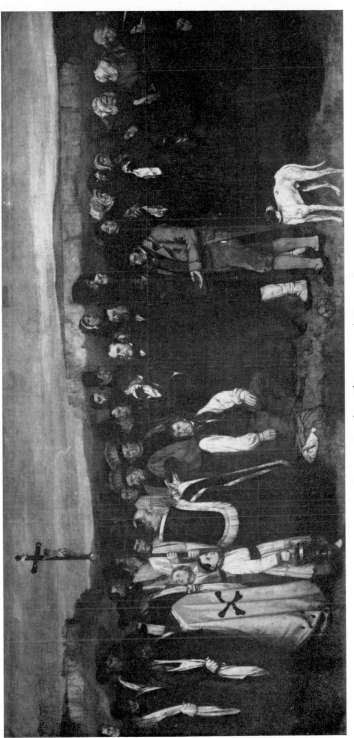

20. Gustave Courbet. *L'Enterrement à Ornans*. Louvre.

21. Édouard Manet. *Olympia*. Louvre.

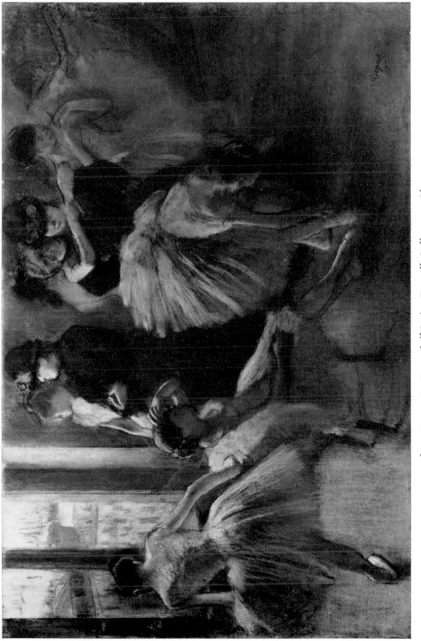

22. Edgar Degas. *Le Foyer de l'Opéra*. Burrell Collect on, Glasgow.

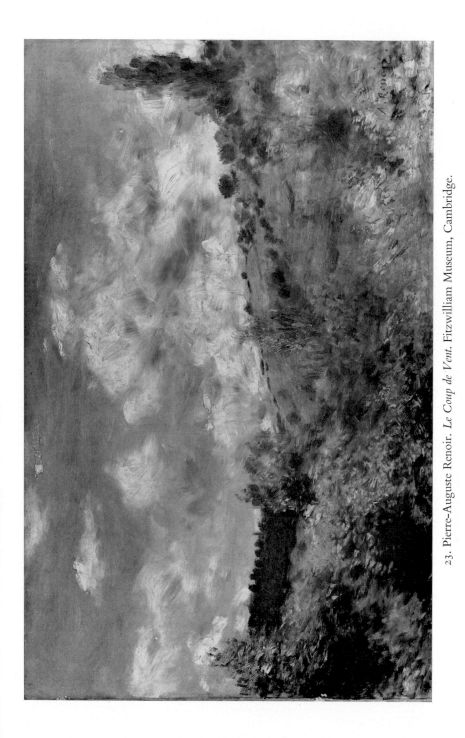

23. Pierre–Auguste Renoir. *Le Coup de Vent*. Fitzwilliam Museum, Cambridge.

24. Claude Monet. *Antibes*. Courtauld Institute Galleries.

25. Paul Cézanne. *La Montagne Sainte-Victoire.* Courtauld Institute Galleries.

26. Vincent Van Gogh. *An Orchard near Arles*. Courtauld Institute Galleries.

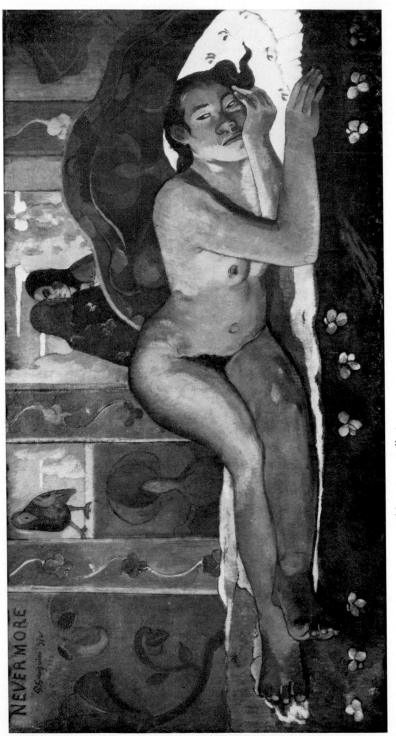

27. Paul Gauguin, *Nevermore*. Courtauld Institute Galleries.

28. Georges Seurat, *Une Baignade à Asnières*. National Gallery.

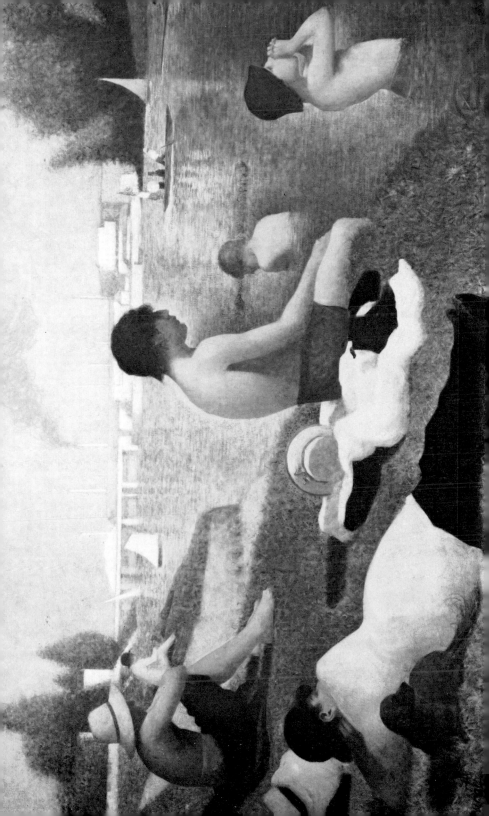

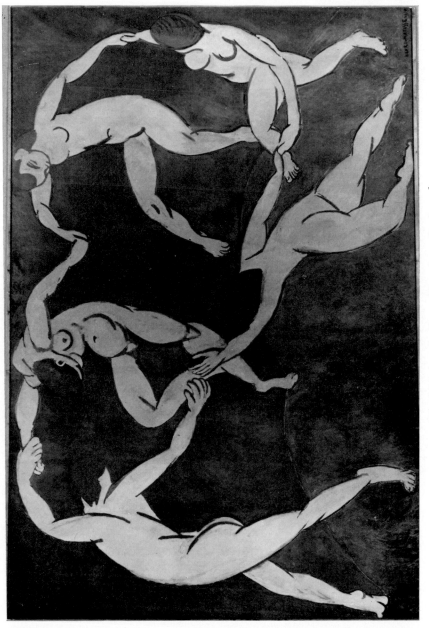

29. Henri Matisse. *La Danse*. Hermitage, Leningrad.

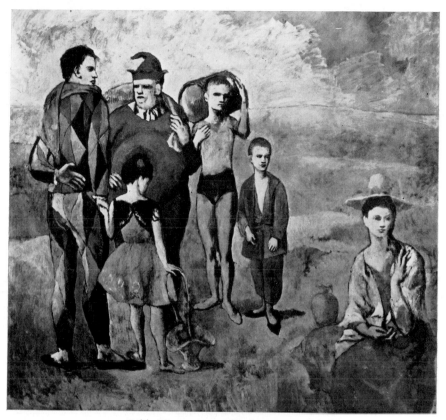

30. Pablo Picasso. *Les Saltimbanques*. National
Gallery, Washington.

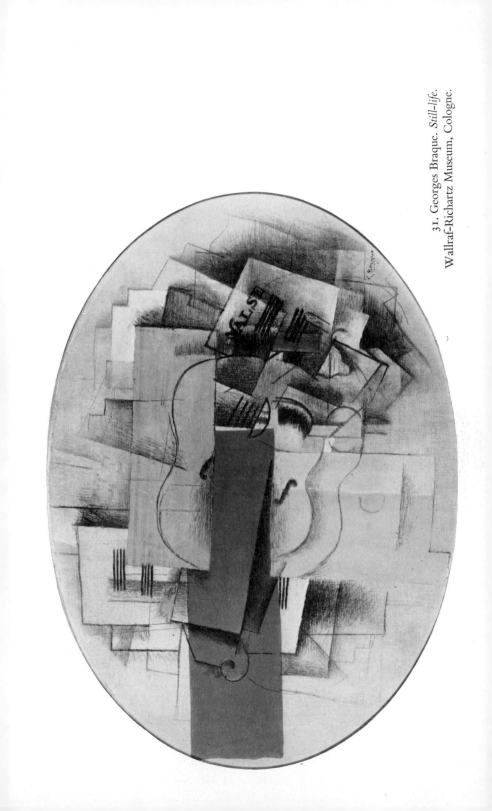

31. Georges Braque. *Still-life.*
Wallraf-Richartz Museum, Cologne.

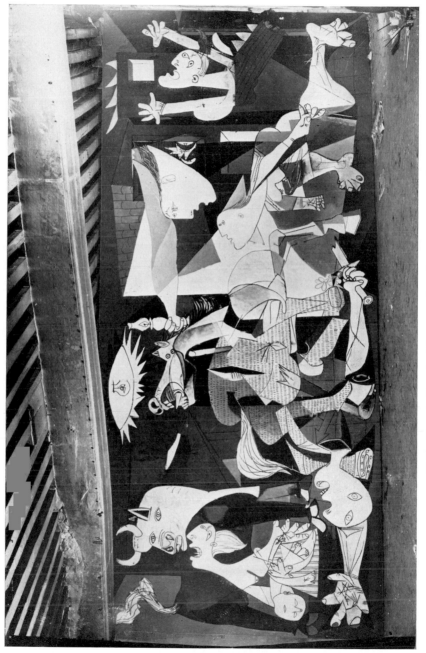

32. Pablo Picasso. *Guernica*. Museum of Modern Art, New York.